Thinkers for Architects

Architects have often looked to philosophers and theorists from beyond the discipline for design inspiration or in search of a critical framework for practice. This original series offers quick, clear introductions to key thinkers who have written about architecture and whose work can yield insights for designers.

Deleuze and Guattari for Architects
Andrew Ballantyne

Heidegger for Architects
Adam Sharr

Irigaray for Architects
Peg Rawes

Irigaray

for

Architects

Peg Rawes

 Routledge
Taylor & Francis Group

LONDON AND NEW YORK

First published 2007
by Routledge
2 Park Square, Milton Park, Abingdon, OX14 4RN

Simultaneously published in the USA and Canada
by Routledge
711 Third Avenue, New York, NY 10017, USA

Routledge is an imprint of the Taylor & Francis Group, an informa business

© 2007 Peg Rawes

Typeset in Frutiger and Galliard by
Florence Production Ltd, Stoodleigh, Devon

British Library Cataloguing in Publication Data
A catalogue record for this book is available from the British Library

Library of Congress Cataloguing in Publication Data
Rawes, Peg.
 Irigaray for architects/Peg Rawes.
 p. cm. – (Thinkers for architects series)
 Includes bibliographical references and index.
 1. Irigaray, Luce. 2. Architecture – Philosophy. I. Title.
 B2430.I74R39 2007
 194 – dc22 2007013346

ISBN10: 0–415–43132–8 (hbk)
ISBN10: 0–415–43133–6 (pbk)
ISBN10: 0–203–93418–0 (ebk)

ISBN13: 978–0–415–43132–3 (hbk)
ISBN13: 978–0–415–43133–0 (pbk)
ISBN13: 978–0–203–93418–0 (ebk)

Contents

Series Editor's Preface

Adam Sharr

Architects have often looked to thinkers in philosophy and theory for design ideas, or in search of a critical framework for practice. Yet architects and students of architecture can struggle to navigate thinkers' writings. It can be daunting to approach original texts with little appreciation of their contexts and existing introductions seldom explore architectural material in any detail. This original series offers clear, quick and accurate introductions to key thinkers who have written about architecture. Each book summarizes what a thinker has to offer for architects. It locates their architectural thinking in the body of their work, introduces significant books and essays, helps decode terms and provides quick reference for further reading. If you find philosophical and theoretical writing about architecture difficult, or just don't know where to begin, this series will be indispensable.

Books in the *Thinkers for Architects* series come out of architecture. They pursue architectural modes of understanding, aiming to introduce a thinker to an architectural audience. Each thinker has a unique and distinctive ethos, and the structure of each book derives from the character at its focus. The thinkers explored are prodigious writers and any short introduction can only address a fraction of their work. Each author – an architect or an architectural critic – has focused on a selection of a thinker's writings which they judge most relevant to designers and interpreters of architecture. Inevitably, much will be left out. These books will be the first point of reference, rather than the last word, about a particular thinker for architects. It is hoped that they will encourage you to read further; offering an incentive to delve deeper into the original writings of a particular thinker.

The first three books in the series explore the work of: Gilles Deleuze and Félix Guattari; Martin Heidegger; and Luce Irigaray. Familiar cultural figures, these are thinkers whose writings have already influenced architectural designers and

critics in distinctive and important ways. It is hoped that this series will expand over time to cover a rich diversity of contemporary thinkers who have something to say to architects.

Adam Sharr is Senior Lecturer at the Welsh School of Architecture, Cardiff University, and Principal of Adam Sharr Architects. He is author of *Heidegger's Hut* (MIT Press, 2006), *Heidegger for Architects* (Routledge, 2007), joint editor of *Primitive: Original Matters in Architecture* (Routledge, 2006) and Associate Editor of *arq: Architectural Research Quarterly* (Cambridge University Press).

Illustration Credits

All illustrations courtesy of Smout Allen

Acknowledgements

I would like to thank the following people for their support during this project: my students at the Bartlett School of Architecture, UCL; Fiona Candlin, Joanne Morra and Jane Rendell for their insightful comments on drafts; Adam Sharr, Series Editor of *Thinkers for Architects* and Caroline Mallinder at Routledge. Also, thanks to Anna Greenspan for conversations about Irigaray over the past 10 years, and to Christine Battersby for her rigorous introduction to Irigaray's work as part of my graduate studies. Thanks also to Laura Allen and Mark Smout for permission to use their images. Finally, thanks to Tom for his continual encouragement.

Introduction

This book provides architects with an introduction to the work of French thinker, Luce Irigaray. Referring to a selection of her publications since her first controversial book, *Speculum de l'autre femme* (1974) and her most recent collection of essays, *Key Writings* (2004), I explore ways in which her work specifically engages with architectural design, history, theory and criticism.

Irigaray's writing contains numerous discussions about the importance of space and spatial relationships between women and men in Western culture, which are also central to architectural design, history, theory and criticism. She refers to physical and architectural spaces (e.g. houses, passages, paths, doorways, thresholds, boundaries, copulas, porticos and bridges) and geometric ideas (e.g. circles, diagonals, inside/outside relations or envelopes). She also examines methods and techniques of constructing space that are used in architecture, including: surveying and measuring procedures; mathematics and geometry; topology and topography; and the history of ideas of space, time and matter. In addition, Irigaray examines how visual, material and linguistic systems of representation are 'architectonic'; for example, in her examination of the textual, discursive, philosophical and technical expressions that constitute the individual subject and space in Western culture.

However, Irigaray's ideas about space and architecture are not simply neutral and *unsexed* references to architectural forms of spatial organisation. Instead, her interest in these modes of cultural expression is always informed by her belief that men and women express themselves differently.

Irigaray's ideas are valuable for architects because she examines how gender and subjectivity construct our experiences of Western culture and architecture.

The 'sexed subject' is a term that Irigaray uses throughout her career. In her writing up to the mid-1980s it is exclusively concerned with women and their expressions. However, in her later publications, the term is developed so that it *also* represents men who seek to rethink male subjectivities (i.e. ideas relating to the self), as distinct from traditions that refer to universal ideas of the male subject in Western culture. Therefore, for Irigaray, Western culture is never simply a reflection of a universal idea of the person or subject. Consequently, her ideas may be best understood with reference to specific examples of architectural design, history, theory and criticism that also prioritise the importance of different genders and subjectivities for architecture.

Irigaray's ideas are valuable for architects because she examines how gender and subjectivity construct our experiences of Western culture and architecture. In particular, her writings explore the ways in which Western culture informs or limits the needs and desires of the individual, especially with respect to women. Irigaray argues that 'sexed' expressions of women and space are needed so that we can properly understand Western culture and the experience of being women and men. For Irigaray, the way in which men and women express themselves *differently* is therefore inherently connected to Western culture's institutions, languages or systems of knowledge and modes of self-expression. So, an individual's sexed subjectivity is integral to the production and reception of architecture and the built environment; for example, it informs ideas of matter, space and time; expresses the physical and the psychological experiences of inhabiting architecture in modern Western cultures; constructs the social, intellectual and professional structure of the different branches of the discipline and; informs the way in which architectural design, history, theory and criticism are related to each other. As a result, her work is a valuable source through which to examine the *different* ways in which architecture and the built environment are sexed cultures.

Irigaray's publications are prolific, including the original texts in French and Italian, and subsequent translations into Dutch, English, German, Spanish, Chinese, Japanese, Korean and Hebrew. This book focuses on texts that are available to English-speaking readers. However, the combination of her bilingual skills, the different linguistic origins of vocabulary which are located in

the Romance languages and English especially, together with Irigaray's interest in etymology, produce different interpretations of meaning across the translations. The reader will therefore benefit from being sensitive to the way in which the meaning of words differ between the original French and Italian texts and the English translations; for example, the multiple meanings generated by the feminine and masculine pronouns, 'elle' and 'il' (and 'lui' or 'la') in the original texts, versus their translation into 'he', 'she', 'the' and 'it', in the English translations.

I refer to five key works by Irigaray:

Speculum of the Other Woman (1974/1985)
This Sex Which Is Not One (1977/1985)
An Ethics of Sexual Difference (1984/1993)
The Irigaray Reader (1991)
Key Writings (2004).

In addition, I refer to *selected* essays in another nine publications:

Marine Lover: Of Friedrich Nietzsche (1980/1991)
The Forgetting of Air: In Martin Heidegger (1983/1999)
To Speak is Never Neutral (1985/2002)
Thinking the Difference: For a Peaceful Revolution (1989/1993)
Je, Tu, Nous: Towards a Culture of Difference (1990/1993)
I Love to You: Sketch of a Possible Felicity in History (1992/1996)
Democracy Begins Between Two (1994/2001)
To Be Two (1994/2001)
The Way of Love (2002).

Also, by highlighting the ideas in Irigaray's writing that are most relevant for exploring the practical, social, political and cultural processes involved in architecture, I do not therefore devote as much attention to Irigaray's discussions about linguistics and politics as researchers from literature, women's and cultural studies. Readers are also advised not take these sources as an all-encompassing blueprint for architectural ideas or the basis of a universal

architectural language and method. Rather, the aim of this book is to augment the development of informed *sexed* historical, critical and creative designing, thinking, writing and speaking in all aspects of architecture.

Below, a short introduction to Irigaray's biography and intellectual career leads into a contextual outline of her ideas in relation to discussions of subject-theory, gender and feminism that exist in architectural design, history, theory and criticism. Six thematic chapters then explore Irigaray's ideas about subjectivity, space and time, the body and sensory perception, science and politics. In each chapter, I refer to short extracts of her writing in order to give readers an insight into her different techniques of writing, thinking and speaking. In addition, each chapter briefly refers to examples of buildings, design projects, essays and books by designers, historians, theorists and critics who also explore sexed forms of architecture. Finally, each chapter ends with a series of dialogue questions to further stimulate the reader's exploration of the relationship between his or her ideas, and the design and interpretation of architecture and the built environment. At the end of the book, an Appendix provides guidance on how to read Irigaray's texts, together with selected references and a list of additional publications that provide further contexts for developing understandings of her work.

Situating Irigaray

Luce Irigaray was born in 1930 and has French nationality. Growing up in Belgium to parents with Belgian, Italian and French ancestry, Irigaray's academic training began in Louvain, Belgium, where she studied for a degree and then completed a doctorate in French and Philosophy in 1955. After teaching in secondary education for a number of years she took a second degree in psychology and a Diploma in psychopathology at the Sorbonne in Paris. Also during this period she trained as a psychoanalyst and attended Jacques Lacan's seminars on psychoanalysis. Then, from 1964, she worked as a researcher at the National Centre for Scientific Research, later becoming a research director at the Centre in 1986. Between 1970 and 1974 she taught at the University of Vincennes, and was a member of the Ecole Freudienne de Paris. In 1973 she submitted two further doctorates, one on poetics and psychopathologies, and *Speculum de l'autre femme*, which was rejected by the University and resulted in her leaving her teaching position. However, *Speculum* was very quickly published, in 1974, and Irigaray's subsequent career has been significant, including: receiving international visiting professorship appointments; giving international lectures and seminars; and working with feminists, women's groups and democratic movements, especially in northern Italy (for further discussion of Irigaray's biography and intellectual career, also see Margaret Whitford's introduction to *The Irigaray Reader* [1991b] and Irigaray's preface and section introductions to *Key Writings*).

Broadly speaking, three phases of Irigaray's writing can be observed in her work from 1974 to the current day. Irigaray's experiences of academic training are most strongly reflected in the first phase of her writings from 1973 to the mid 1980s. First, the rejection of *Speculum* and her break from Vincennes partly contribute towards her fierce criticism of how modern Western culture constructs social and gender relations; in particular, the control of ideas that academic disciplines, such as philosophy and psychology, exert on their

respective members. Second, texts from this period are characterised by her intensive critique (i.e. criticism) of the physical and psychological construction of gendered subjectivity in Western culture, which she calls 'sexual difference'. Principally, this involves her in analysing philosophical, psychoanalytic and linguistic texts to show how they construct our physical and psychological experiences of being women and men. Irigaray's essays and books from this period, therefore, focus especially on the structures, languages and expressions that consciously *and* unconsciously inform cultural ideas about the different ways in which women and men express themselves.

A second mode of writing is also evident in texts written between the early 1980s and the mid 1990s. Here, Irigaray expands her criticism of Western culture into a more explicitly poetic style of writing that explores physical forms of sexual difference (e.g. concerning the body) and psychic forms of sexual difference (e.g. concerning our desires and language). These texts also develop 'performative' methods of writing that promote historical and mythological modes of feminine expression, and make links between Irigaray's ideas and those of other contemporary thinkers working in France at the time, especially, Hélène Cixous and Julia Kristeva.

Irigaray's work during the 1970s and early 1980s also needs to be considered in relation to a number of different intellectual contexts. First, her work is developed after Simone de Beauvoir's writing on gender and politics in the 1940s and 1950s (e.g. *The Second Sex*, 1949). Second, her ideas are informed by 'post-structuralist' philosophical debates, and the political and social action in France during the late 1960s. Alongside Cixous and Kristeva, Irigaray shares a criticism of Western culture for failing to properly express the needs and desires of women, yet each also privileges feminine forms of linguistic expression (that some commentators have called '*écriture féminine*'). Cixous, for example, 'deconstructs' cultural and aesthetic understandings of woman and femininity (e.g. *The Newly Born Woman*, 1975), and Kristeva analyses the ambivalent, sometimes 'abject', expression of femininity and motherhood (e.g. *Desire in Language,* 1980). In addition, these writers' ideas reflect the work of other significant French post-structuralist philosophers who were also exploring new methods and concepts of politics and material culture at this time,

including: the collaborative writing of Gilles Deleuze and the psychoanalyst, Felix Guattari (e.g. *A Thousand Plateaus*, 1980); Jacques Derrida's philosophy of 'deconstruction' (e.g. *Writing and Difference*, 1967); and Francois Lyotard's *Libidinal Economy* (1974). In each case, these philosophers seek to challenge the dominant structuralist interpretations of material, political and social culture.

Finally, a third strand of writing is evident in Irigaray's texts written from the late 1980s to the current day, which draw from her involvement in contemporary political debates and the women's movement. As a result, her writing from this period emphasises the political, social and cultural debates about gender taking place outside academic research, and particularly reflect Irigaray's involvement in contemporaneous political debates in the Italian Communist Party in Bologna, Italy. In contrast to her detailed academic reading of key philosophical and psychoanalytic texts, writings from this later period are therefore situated within the wider contexts of the political and cultural construction of identity and citizenship. In addition, these later theories of 'sexuate culture' are more explicit about supporting the social and political needs of men, as well as women.

During her career, Irigaray adopts different strategies of engaging with historical and contemporary thinkers and their respective ideas. In her earlier works, these encounters are frequently confrontational and focus on questions about how traditional Western culture is inadequate for women's needs; for example, she interrogates who is allowed to generate, control, accept or reject ideas in the disciplines of psychoanalysis and philosophy, which she considers to be symptomatic of the limitations placed on women by Western culture. In the later works, however, Irigaray's focus on multiple (or 'feminine') forms of authorship shifts from her intense analyses of philosophy and psychoanalysis to an interest in dialogue, exchange and collaboration (and, in many respects, these changes also reflect the increased interest in cross-disciplinary methods of working in architecture that has developed over the past 20 years). Throughout her career, however, her examination into who is actively involved in the production of ideas, who is rewarded and acknowledged as author, and who is excluded or omitted, run consistently throughout all her writings.

Irigaray adopts different strategies of engaging with historical and contemporary thinkers and their respective ideas.

Irigaray has also written a few essays specifically on architecture and the visual arts. These essays, however, tend not to be as successful because they refer to generalised descriptions of the disciplines. In particular, they do not show a strong enough understanding of the considerable work that has been undertaken by architects, artists, historians, theorists and critics in the disciplines to develop 'sexuate' forms of visual culture, in theory and in practice, over the past 35 years (and so I do not refer to these particular essays below). Irigaray's shift from close analytical readings of academic thinkers into broader cultural contexts can sometimes therefore reduce their direct value for architecture. Despite these cautionary points, however, the value of Irigaray's ideas for developing innovative, creative, interdisciplinary *and* sexed architecture by contemporary and future architects is substantial, and deserves proper attention and study.

Irigaray and architectural design, history, theory and criticism

Irigaray's ideas also need to be understood within the context of two quite distinct traditions that examine different modes of architectural production and interpretation: first, European, US and Australian post-structuralism and, second, Anglo-American left-wing political thinking. Over the past 30 years these two traditions have been particularly influential for architectural design, history, theory and criticism which explore *difference* in the material, physical, aesthetic, social, economic and political processes that construct physical architectures and the participating architects and/or users.

As I outlined earlier, Irigaray's ideas are developed from French post-structuralist thought and from her response to Western philosophy and psychoanalysis. Traditionally, philosophy and psychoanalysis view the individual subject to be composed of the disruptive complex relationship between his or her material characteristics and psychological characteristics. However, post-structuralists have developed these theories to argue that all individual subjects, men

and women, have a *unique* subjectivity that expresses his or her *specific* political, social and cultural position. In addition, because any person or idea is *always* composed of fluctuating physical and psychological qualities, post-structuralists argue that categorising the world into simple finite definitions (e.g. *art* versus *science*, *design* versus *theory*, *drawing* versus *writing* or *women* versus *men*) misinterprets the complexity of reality. Such polar oppositions are too simplistic. Post-structuralist use of the terms 'woman' or 'man' therefore refer to complex notions of subjectivity that do not simply designate a difference in gender.

In this respect, a post-structuralist architectural designer, historian, theorist or critic will often consider architecture to be composed of dynamic inter-relationships *between* its different forms of expression and constituent participants. The built form, visual designs, such as drawings or models, and written texts will all be taken as necessary inter-related materialisations of the discipline. In addition, many of these individuals will *practice across* history, theory, criticism and design, developing methods that intertwine one or more branches of architecture into connected processes, rather than positioning them in opposition to each other. Below, and in the following chapters, I refer to examples of practitioners who develop methods through which criticism and design, or historical analysis and visual poetics, are intertwined.

So, for Irigaray, and these post-structuralist architectural *practitioners,* architecture also reflects the complex cultural construction of the individual. In addition, two sub-groups of post-structuralist architectural practitioners can be distinguished; first, architectural practitioners who refer explicitly to Irigaray's work, and a second, larger group of individuals who examine architecture in the context of post-structuralist subject-theories, but do not directly refer to Irigaray's ideas.

In the first group, Vanessa Chase, Gülsüm Baydar, Jane Rendell, Katarina Rüedi and Mark Wigley's architectural history and criticism are examples of post-structuralist practitioners who have used Irigaray's work to critique modern architecture in relation to feminism, ethnicity, philosophy and the visual arts.

Second, practitioners working in Australia, Europe and in the US, have also explored Irigaray's political and aesthetic ideas of 'in-between' or imaginary spaces and passages to develop new modes of architectural practice that challenge the traditional theory/practice divide; for example, interdisciplinary design-text projects by Jennifer Bloomer, Doina Petrescu and Jane Rendell.

The second strand of post-structuralist practitioners includes men and women whose buildings, designs, history, theory and criticism reflect some of Irigaray's ideas about the dynamic formation of architecture and male and female subjectivity, but do not refer directly to Irigaray's thinking – for example Diana Agrest, Beatriz Colomina, Mary McLeod, Zeynep Çelik, Debra Coleman, Elizabeth Diller, Merrill Elam, Alice T. Friedman, Hilde Heynen, Francesca Hughes, Catherine Ingraham, Françoise-Hélène Jourda, Martine de Maeseneer, Amy Landesberg, Meaghan Morris, Lisa Quatrale, Barbara Penner, Charles Rice and Henry Urbach.

Some of these post-structuralist practitioners also identify themselves with feminist politics. Others, while recognising that feminism is as an important historical tradition, do not consider it to be the most appropriate form of identification because of the need to promote the physical and psychological richness of all subjectivities (e.g. multi-cultural, male, female, disabled, gay, lesbian or transsexual subjects). Irigaray, for example, resists being called a feminist, despite the focus of her writing on feminine subjectivities, her close affiliations with feminists in academia and her support for the women's movement.

In contrast, architectural designers, historians, theorists and critics who work within the Anglo-American tradition frequently identify themselves with feminism, gender-politics and the women's movement because of their political interest in social and economic equality for women and 'other' marginal identity groups in Western society. Engaging with these left-wing critiques of social and economic organisation, architectural institutions and professions and their respective professional conventions, architects, such as Frances Bradshaw, Denise Scott Brown, Susana Torre and Sarah Wigglesworth write of the need for gendered understandings of architectural practice that provide actual material,

economic and social equality for women, both in the profession and as users of architecture. Alternatively, Dolores Hayden, Leslie Kanes Weisman and Daphne Spain have developed feminist critiques of architectural space and the role of women in modern urban planning and in the inhabitation of the built environment; and Lynne Walker, Sara Boutelle, and Gwendolyn Wright's research into the work of women architects are examples of feminist architectural history.

Several edited collections of essays and projects have been published during the last 15 years that include examples of work by these architects, historians, theorists and critics from the post-structuralist and Anglo-American traditions, as well as many others who are not referred to here. Some of these publications also specifically discuss the value of Irigaray's ideas for architecture in relation to the different strands of feminist, gender-based and subject-theory research and practice that reveal the diverse social, professional, political, cultural and aesthetic debates in architectural design and text-based practices. *Sexuality and Space* (1992), *Architecture and Feminism* (1996), *Desiring Practices: Architecture, Gender and Interdisciplinarity* (1996), *Gender, Space, Architecture: An Interdisciplinary Introduction* (2000) and *Negotiating Domesticity: Spatial Productions of Gender in Modern Architecture* (2005) include essays and projects that refer directly to Irigaray's ideas. Mark Wigley's closing essay in *Sexuality and Space* explores the 'house of gender' with reference to Irigaray's analysis of psychoanalysis (Colomina 1992, pp. 387–389). Debra Coleman's introduction to the collection, *Architecture and Feminism*, argues for the necessity of feminist examinations of women's subjectivity in architectural history, theory, criticism and design, through post-structuralist theories of the subject that include Irigaray's examination of 'woman' (Coleman *et al.* 1996, pp. ix–xvi). Jane Rendell's introductions to the three parts of *Gender, Space, Architecture* contextualise Irigaray's work in relation to the different traditions of post-structuralist subject-theory, cultural geography and Marxist spatial theories, feminist and gender studies, to construct an interdisciplinary understanding of architecture (Rendell *et al.* 2000, pp. 15–24, pp. 101–111 and pp. 225–239). Hilde Heynen's introductory essay to *Negotiating Domesticity* outlines the different interpretations of subjectivity that distinguish Anglo-American approaches versus the French post-structuralism that characterises Irigaray's

thinking (Heynen and Baydar 2005, p. 6). In addition, *The Sex of Architecture* (1996) and *The Architect: Reconstructing Her Practice* (1996) are valuable edited collections of essays and projects that do not specifically refer to Irigaray's ideas, but do provide important contexts through which to explore post-structuralist, feminist and Anglo-American analyses of subjectivity, sexuality and gender in Western architectural education, practice, history, theory and criticism.

These diverse modes of design, history, theory and criticism, and the subject positions from which they are produced, show that architecture is an inherently differentiated and sexed discipline that reflects the dynamic cultural relationships existing *between* sexed subjects and spaces. Moreover, each of the different strands outlined above are linked to Irigaray's ideas by the belief that *sexed subjects*, *sexed spaces* and *sexed architecture* are vital for the benefit of all cultures. The following chapters explore these relationships in more detail. However, Irigaray, and the majority of the European and North American architectural practices that I refer to below, also focus mainly on Western forms of these relationships (although Gülsüm Baydar, Zeynep Çelik, Leslie Naa Nor Lokko, Doina Petrescu and Jane Rendell's work does engage with non-Western architectures). With the recent global architectural developments taking place, for example, in China, India, South East Asia, the African continent and South America, there are therefore many other *multi-cultural sexed* architectures that are *yet* to be explored.

The six chapters below explore how Irigaray's writing can enable us to understand how architectural design, history, theory and criticism always reflect an individual's sexual difference, and how our different subjectivities may contribute to the production and experience of architecture. They examine the potential for Irigaray's ideas to reveal *new contexts* for exploring the sexed architectural design, history, theory and criticism that already exists in the discipline. In addition, they consider how her ideas may contribute towards building *new expressions* of sexed architecture, architects, users and cultures.

Doubles and Multiples

In this chapter I explore Irigaray's theories of *sexual difference* and the *sexed subject*. Sexual difference is important for architects because it shows how male and female subjects are culturally and biologically constructed. In addition, Irigaray's analysis of sexed subjects is reflected in the different ways that poststructuralist designers, historians, theorists and critics have explored how architecture is occupied, designed and built.

For Irigaray, culture is always constructed out of complex historical and social relations, and an individual is *always* differentiated by his or her sexed

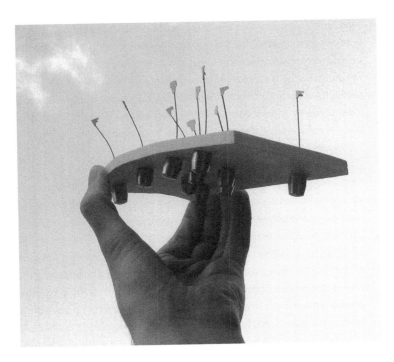

subjectivity. In particular, she argues that Western culture, especially the disciplines of philosophy, psychoanalysis (and architecture), organise material and social structures through homogenous (i.e. unchanging) and hierarchical systems. Under these traditions distinct individuals, actions, practices, spaces, materials and ideas are brought together under laws of homogeneous universality, whereby *particular* differences are ignored in favour of similarity. For example, traditional versions of Western architecture are dependent upon

. . . culture is always constructed out of complex historical and social relations, and an individual is always differentiated by his or her sexed subjectivity.

the transmission of formal stylistic traits in which complex periods of diverse invention are represented by the 'universal' work of a few architects who represent the 'paradigm' of a particular period of architectural development. Furthermore, preference may be given to male architects, so that the specific cultural, economic and sexed contexts of architectural production are also ignored in favour of a single-gendered definition of 'the architect'. Recent feminist, Marxist and post-structuralist theorists, for example, have shown that these accounts ignore the sexed nature of architectural production and use so that the cultural value of local adaptation or innovation of styles, theories, techniques and materials is lost.

So the production of the built environment is a highly complex and dynamic social organisation. Inside its cultural, educational, regulatory and professional institutions, and between them and the related public and private professional partnerships, a diverse range of economic, social, political and sexed individuals construct; its design, technology, legal, engineering and aesthetic realms; the relationship between the architect and the client, and the architect and the planner; the process of designing a specific space, room, area, building, region or urban environment. In addition, design involves processes that immediately produce multiple spaces; for example, in drawing or modelling a boundary line or an external wall of a private house there is also an immediate differentiation

made between the inside and outside spaces, the privacy of the 'home' and the public space of its neighbourhood.

Architectural ideas and practices are therefore intrinsically concerned with producing heterogeneous spaces (i.e. a multiple range of spatial qualities); even in the most tectonic, ordered or formalist designs, architecture is a social and cultural *process* through which *more than one space or architecture is constructed at the same time.* Just as individual men, women and children are unique, architectural design is always more complex than reducing architectural buildings and spaces to the representation of a predetermined idea or 'origin'. Irigaray's writing therefore informs architectural designers, historians, theorists and critics who argue that architectural spaces, architects or users are heterogeneous, and who challenge the limited application of inflexible or homogenous (i.e. uniform) procedures and methods.

Sexual difference

Irigaray's theory of sexual difference is developed out of philosophical and psychoanalytic theories of subjectivity. First, subjectivity is the physical or biological sex (i.e. female or male subjects). Second, it is how an individual expresses his or her sexuality (e.g. feminine, masculine, lesbian, gay or transsexual subjects). For Irigaray, sexual difference is fundamental to each and every aspect of how a woman or man lives. It constructs the different ways that men and women think, speak, listen, write, draw, design, model, engineer, act, move, love, desire, play and work. In addition, it determines the cultural formation of language, knowledge, histories and myths that define men and women. Moreover, women's sexual difference is absolutely distinct from men's, and Irigaray examines how women's experiences are consistently overlooked, repressed or removed from histories and theories in Western culture. This strategy is particularly clear in her examination of how philosophy and psychoanalysis have misrepresented women.

Philosophy defines the relationships between an individual's mental and physical powers of representation and the world in which they are situated. Irigaray argues that, although philosophy promotes individual action and experience,

it is *always* identified with male, masculine, or at the very least a 'neutral' subjectivity which does not express the actual physical, mental and spiritual differences of women. For Irigaray, the traditional philosophical subject has no sexual difference and women are aligned with the realm of non-representational ideas (e.g. immaterial, theological or virtual ideas). Put more strongly, she argues that the female sexed subject – woman – does not *yet* actually exist in Western philosophy. In particular, she develops these ideas by examining the negative, physical, social, psychological, historical, political and theoretical ideas which philosophy uses to describe 'woman' and her feminine attributes. She concludes that woman and feminine qualities are cast in negative terms in Western philosophy: woman is passive, desiring, physical, improper, incomprehensible, excessive, incomplete, irregular, imitative, imaginary, inaccessible, irrelevant or forgotten. In contrast, Irigaray observes that the male subject is characterised in positive terms: he is active, reasoning, intellectual, clear, proper, complete, autonomous, singular, constant and self-determining.

Irigaray's theory of sexual difference is also informed by psychoanalytic theories of paternal, maternal and childhood relations. Developed as a branch of psychology by Sigmund Freud in the late nineteenth century, and by Jacques Lacan's twentieth-century readings of Freud's work, Irigaray defines psychoanalysis as 'the science of desire' through which an individual's active and repressed feelings construct themselves and desires for other people.

In particular, she argues that Freud's theories of female sex and sexuality, and consequently female relationships with others, is constructed out of a girl's childhood realisation that she lacks a penis. In contrast, a man's sexual identity, and hence his relationships with others, is constructed out of the fear that he may lose his penis (by the threat of castration). Sexual difference in men and women is therefore constructed as a dynamic (i.e. changeable) physical and psychological experience between individuals and in their relationship to objects in the world. Subsequently, Lacan's psychoanalytic writing and teaching developed Freud's work to explore how relationships between men, women, fathers, mothers and the child are expressed through language. Central to his theory, is the view that the subject is a fundamentally fractured and discontinuous collection of thoughts and desires, which are held together by

the acquisition of language. For Lacan, sexual difference is constructed through the way in which we use language and symbols – e.g. the words, 'mother', 'I', 'father' or 'you' – in order to construct the visual, spatial, physical and emotional links or divisions between ourselves and others.

For Irigaray, psychoanalysis informs her theory of sexual difference because it confirms that biological and psychic desires do also constitute women's, mothers', girls' and daughters' experience of sex. Throughout her writing, however, Irigaray shows that Freud and Lacan's theories are seriously problematic for a positive theory of sexual difference for women. Although Freud and Lacan show that sexual difference is integral to men and women, both suggest that it is a fundamentally unstable formation of identity for women.

Irigaray's early writing is also reflected in the ideas of feminist architects, critics, historians and theorists working during the 1970s and 1980s who promote the importance of gender relations and the status of women as clients, practitioners and users of space (e.g. Wright 1981; Hayden 1984; and Kanes Weisman 1992). Sharing a similar desire for promoting women's lives as these Anglo-American publications, Irigaray's texts from 1973 to the mid 1980s also privilege the biological differences between men and women, especially in her examination of the 'formal' biological and physical differences between the male and female sex organs. In this respect, her promotion of 'essential' differences is most meaningful when it is understood as a reflection of the historical context in which these theories developed out of the political movements for 'marginalised' groups (i.e. second-wave feminism, class-based, multi-cultural, anti-war and gay activism) between the late 1960s and 1980s in Europe, North America and Australia (see Rendell et al. 2000). For these theorists and activists an individual's physical and biological characteristics therefore represented a fundamental and *positive* difference between themselves and the dominant patriarchal notion of the individual which was generated by the homogenous desires and institutions of white male culture.

More recently, Irigaray's theory of the sexed subject reflects the shifts towards new theories of subjectivity for men and women that have developed since the 1990s. These theories have developed out of research into male and female

sexed corporeal forms of embodiment (i.e. bodily qualities) and Irigaray's later writings also share these more *positive* forms of communication between men and women. In particular, *I Love to You: Sketch of a Possible Felicity in History* (1996) and *The Way of Love* (2002b) show how *sexed* male subjects communicate their feelings and desires in politics; for example, when they engage in non-hierarchical dialogue that is derived from traditionally female modes of communication. Irigaray also refers to this 'sexuate culture' in *Je, Tu, Nous: Towards a Culture of Difference* (1993b, pp. 9–16) and, in the preface of her most recent collection of essays, *Key Writings*, she develops her analysis of 'sexuate difference' between men and women, writing:

> man and woman do not belong to one and the same subjectivity, that subjectivity itself is neither neutral nor universal. [. . .] The encounter between them requires the existence of two different worlds in which they could enter into relation or into communication after recognising that they are irreducible the one to the other (2004, p. xii).

So, Irigaray's ideas of sexual difference focus on the different physical and psychic states that construct sexed subjects and, consequently, the *sexed architect's* experiences of the world, depending upon the context in which he or she is situated. In addition, sexual difference is partly derived from 'essentialist' theories, which refer to the biological and physical differences between the sexes. This early form of expressing the biological and physical differences between men and women also retains most value when it is considered in light of recent shifts in subject theories which return to the importance of biological difference for male and female subjectivity. In these newer contexts, the physiological and biological differences that distinguish men and women are considered to be dynamic processes of physical and psychic activity that, in turn, inform the sexual, social and political relations between men and women.

Accordingly, in her early publications, men's sex is defined in relation to his biological sex organ (i.e. the penis). In addition, male sex is reflected in the actions, thinking and symbols that constitute masculine identity in Western 'phallocentric' culture. Irigaray argues that the primary symbol of male sexuality, the phallus, is used in society to describe the dominant masculine modes of

living and communicating; for example, in the essay, 'This sex which is not one', she writes: 'The *one* of form, of the individual, of the (male) sexual organ, of the proper name, of the proper meaning [. . .] supplants, while separating and dividing' (1985a, p. 26).

In contrast, she argues that the biological structure of women's sexual organs (i.e. the two labia or 'lips') represents a distinct kind of sexual difference. She writes that because a woman's specific biology and physiology does not restrict her to one sex organ, she is able to express her emotions and desires through *multiple* places and routes. 'Woman', for Irigaray, therefore has *multiple* sites of arousal, contact, activation and desire: '[the] contact of *at least two* (lips). [. . .] *She is neither one nor two*. Rigorously speaking, she cannot be identified either as one person, or as two. She resists all adequate definition' (1985a, p. 26).

Irigaray goes on to argue that these different physical and biological experiences inform men's and women's cultural experiences of space, especially, in the formation of internal and external spaces. She suggests that a man's subjectivity is derived partly because his sex organ projects from his body, and is externally visible. Women, by contrast, express their sex in a more 'complex' internal *and* external spatial relationship because their sex organs are zones of activity both inside and outside their body (e.g. a woman's lips, breasts, clitoris and vagina):

> His sex (organ) presents itself as something external, through which he can love himself – although this has its own dangers, its own threat of loss or fragmentation. All the same, that organ is on show, on exhibit, presented or represented, even in its movements. This is not true for the female sex organs. [. . .] Love of self on the female side is a more complex experience. The female has always served the self-love of man, obviously. But there is also the fact that the female does not have the same relation to exteriority as the male. Woman is loved/loves herself through the children she *gives birth to*. That she *brings out*. [. . .] And of her 'end.' The (indefinite) series one plus one plus one, etc. (masculine and/or feminine) does not interest her as much as it does the male (1993a, p. 63)

Sexual difference therefore registers the different ways in which men and women physically and psychically experience the world and relate to others.

So, in Irigaray's early writings, biological sex is a significant material aspect of our bodily experience of sexed subjectivity, and she uses these distinctions to develop an argument about the relationship between sex and space. Masculinity is identified with external space because it focuses upon the production of discrete ideas or objects in external spaces. In contrast, feminine space is simultaneously internal *and* external, because no single discrete boundary defines a woman's sexual experience or biological organs. In each case, sexual difference is generated out of distinctly different biological and psychic expressions of subjectivity.

Sexual difference therefore registers the different ways in which men and women physically and psychically experience the world and relate to others. For architectural discussions that relate to these theorisations see, for example, Leslie Kanes Weisman's *Discrimination by Design: A Feminist Critique of the Man-Made Environment* (1992); Meaghan Morris's discussion of phallocentric logic in architecture's fascination with towers, skyscrapers and masculinity (Colomina 1992, pp. 1–52), or Deborah Fausch's examination of the body and architecture (Coleman *et al.* 1996, pp. 38–59).

Sexed subjects

For Irigaray, woman always embodies more than one subject position. In the essay, 'Volume-fluidity', Irigaray examines the multiple social and physical spaces and roles that a woman simultaneously embodies. She is never reducible to a single subject, but is '*double*'; 'Woman is neither open nor closed. She is indefinite, infinite, *form* is never complete in her. She is not infinite but neither is she a unit(y)' (1985b, p. 229). At least two subject positions always construct the experience of being a woman; first, the sexed subject cannot be reduced to a single homogenous subject because of her physical differentiation into two

interconnected elements (i.e. the labia/lips). Second, the combined physical and psychological expression of an individual's sexual difference means that it is an inherently pluralist state: a woman cannot be reduced to any one single form, idea or subject. Just as a woman's sex organs (the labia) cannot be reduced down to separate or disconnected elements, her psychic expressions of sex are intrinsically differentiated, yet always connected. Therefore, for Irigaray, 'woman' is not lacking in psychological or physical powers. Instead, her multiple modes of embodiment confirm her plural existence and, as a result, she cannot be defined as incomplete or inadequate because she is not reducible to a single finite being. This is a complex and dynamic experience of subjectivity that represents a more meaningful expression of the sexed subject's actual multiple psychological and physical experiences of the world. Women are plural because they exist *simultaneously in different subject positions* (i.e. a woman may be a mother, daughter, partner, lover, professional architect, historian, theorist and critic at the same time).

In addition, Irigaray's examination of how the sexed subject and sexed spaces are culturally constructed in the linguistic, institutional and social organisation of home and work also leads her to reject the limited patriarchal division of social and material relations into homogenous, discrete objects and spaces. Sexed subjects are also constructed by the disciplinary and institutional organisations of knowledge in Western society, not just resulting from the biological differences between male and female bodies. In *To Speak is Never Neutral* (2002a), for example, she shows how Western culture ignores the positive attributes of sexed subjects and sexed spaces, such as women's conversations and children's play, and her interrogation of the disciplinary and institutional structures of psychoanalysis, science and linguistics shows how they prevent the sexed subject from being 'properly' expressed.

For Irigaray, all verbal languages and their respective representational symbols directly inform our ability to express ourselves in the world. In *Speculum*, she examines women's multiplicity in relation to the cultural formation of sexual difference in language. She observes, for example, how the linguistic formation of the subject in the pronoun 'I' reflects Western culture's association between

the *single* subject and discrete units of measurement or order. In particular, she argues that it determines the association between finite rational numbers and symbols (e.g. 1, one, God, man) and measurement.

In her early texts, especially in *Speculum*, Irigaray also suggests that Western cultures have prevented the sexed subject from existing in its discourses; for example, in an essay on Descartes' theory of the subject, she argues that Western philosophy limits the subject to discrete rational objects and spaces. In addition, she accuses Descartes of limiting the construction of the world to vision by drawing a parallel between, the 'eye' or vision, and the 'I' or the autonomous neutral subject (1985b, p. 180). Later, in *To Speak is Never Neutral*, Irigaray returns to this issue, arguing that modern science's dependency upon discrete numerical 'truths' also reflects Western culture's linguistic and institutional division of subjects into finite units (2002a, p. 2). In contrast to these rational and neutralising structures, she suggests that the 'sexed I' is a 'new instrument of translation' through which different cultural and physical expressions and languages can be developed (2002a, p. 6). Irigaray's early confrontational readings of philosophers (especially Aristotle, Descartes and Kant) reflect the highly critical position outside the discipline's boundaries that feminist critics adopted between the 1970s and the early 1990s. In the last ten years, however, feminist writers have tended to use less aggressive approaches in order to reveal philosophy's 'blind spots', and to retrieve the hidden, repressed or forgotten histories and concepts of the sexed subject (e.g. Grosz 1995; Plant, 1997; Battersby 1998; Lloyd 2002). In *To Be Two*, for example, Irigaray promotes a new language of sexed subjectivity for men and women out of Merleau-Ponty's philosophy of perception and sensation (2001b, pp. 20–26).

By interrogating the intellectual and cultural structures through which the sexed subject is constructed, Irigaray therefore shows that language is fundamentally tied to his or her physical and psychic experiences of sexual difference. There are also many women and men in architecture whose practices reflect these multiple subject positions in visual and verbal architectural languages; for example, Diana Agrest, Jennifer Bloomer, Raoul Bunschoten, Beatriz Colomina,

Elizabeth Diller, Merrill Elam, Peter Eisenman, Robin Evans, Catherine Ingraham, Greg Lynn, Mary McLeod, Ben Nicholson, Jane Rendell, Neil Spiller, Jeremy Till, Bernard Tschumi, Sarah Wigglesworth and Mark Wigley, among others. These individuals' visual and verbal architectural languages therefore suggest that architecture is not necessarily always a reflection of universal thinking, but indicate that it is composed of multi-faceted aesthetic and sensory modes of expressing the sexed architect and sexed spaces.

Relations and relationships

Architecture is constructed out of the *dynamic* social relationships and processes that construct the built environment. Architectural drawing, modelling, writing, fabrication, as well as the user's occupation and his or her likely adaptation of a given architectural space, are inherently dynamic processes. Unlike some formalist theories of architectural design that limit the value of the individual and social production of space to afterthoughts, Marxist, feminist and post-structuralist interpretations of architecture over the past 30 years have defined its processes in relation to the way that individuals and communities operate *in relation to* their environments. Feminist architectural historians and theorists, for example, have explored the different ways in which sexed subjects engage with each other in the home and at work, and in our relationships and spatial experiences of the city, such as Susan Henderson's discussion of the modern German kitchen (Coleman 1996, pp. 221–253), or Dolores Hayden's critique of modernist gendered space in North America (Hayden 1984). Hilde Heynen and Gülsüm Baydar's edited collection, *Negotiating Domesticity*, also explores these gendered relationships and spaces, for example, in Barbara Penner's examination of the gendered space of the honeymoon suite (2005, pp. 103–120). According to these theories and practices, architecture is therefore constructed as much through the physical relationships that the sexed subject has with others, as with the physical and psychic construction of spatial relationships that are encouraged, prohibited or overlooked in the design of the built environment. Dynamic social and spatial relations *between* individuals who occupy and use it, the different ways in which the individual relates to his or her actions, thoughts, memories, relationships with others, in

different spaces and places, therefore construct the way in which architecture operates in Western society. The use and occupation of architecture also reflects the way in which social, spatial, economic and sexual relations organise the fabrication of architecture. Thus, architectural materials and spaces are related to each other as a result of the dynamic material conditions that construct the sexed subject.

Irigaray privileges these dynamic social and spatial relations in her theory of the sexed subject when she shows that it is constructed through the physical and social relationships that construct families and friendships, professional and intimate relations. She shows, for example, how these *intersubjective* social interactions construct the way in which we define ourselves as daughters, sons, fathers, mothers, lovers, professionals, and political and cultural citizens. In contrast, she shows that systematic thinking limits the subject to an autonomous agent, independent of these real dynamic social relations. So, for example, although Freud and Lacan recognise the importance of physical relationships between individual men and women for our daily psychic experiences, each prevents the sexed subject from existing properly. In particular, she concludes that Freud overlooks the importance of relationships between mothers and daughters (1989, p. 109), and Lacan limits the role of women to the *secondary* position of the mother (1985a, p. 86). As a result, for Irigaray, Freudian and Lacanian psychoanalysis ultimately reflect the negative position that is attributed to women by *hierarchical* Western cultures (i.e. theories of Western culture that privilege the white male subject).

Alternatively, in the essay, 'Commodities among themselves', Irigaray makes a particularly intensive critique of the negative cultural value that is associated with women's sexual difference in *economic* relations. This essay focuses on Karl Marx, another key thinker in the history of Western ideas. Irigaray interrogates his theory of socio-political relations to show that women are placed into a negative hierarchy of relations in which they are devalued to by-products, 'commodities' or 'objects' that are desired, acquired and rejected by society (1985a, p. 192). In addition, she uses Marx's theory of economic relations to critique how women have been placed into

subsidiary positions by patriarchal society when they are required to assume the father's family name. In this respect, Irigaray argues that a Marxist theory of economic and social relationships defines woman as a 'property' of male households, rather than recognising their right to independent self-determination. Thus, she uses the metaphorical link between 'proper' and 'property' in order to show how economic relationships depend upon a principle of self-similarity that undermines the unique, plural, value of women to society. Instead women become associated with 'use-value' and 'properties' of culture; 'For woman is traditionally a use-value for man, an exchange value among men; in other words, a commodity' (1985a, pp. 83–84).

For Irigaray, the formation of the individual in the family and its psycho-social spaces are central to understanding the importance of women in society, and their ability to engage in productive political and social change. This analysis is especially strong in the texts, *Thinking the Difference: For a Peaceful Revolution* (1993c), *Democracy Begins Between Two* (2001a) and *I Love to You*, which examine how the sexed subject informs the political ambitions for 'real' democratic change; for example, in *I Love to You*, Irigaray explores positive relationships between women and men that are embodied in *non-hierarchical* relationships, such as dialogues. These new 'subject to subject relations' (1989, p. 17) also reflect Irigaray's positive personal experiences of working with men and women in the Italian Communist Party in the late 1980s, and indicate to her belief that modern politics must take account of the *non-hierarchical* relationships and communities that women have traditionally constructed in the home, family and community.

'Otherness' and ethical difference

Irigaray's emphasis on non-hierarchical relationships between subjects underpins her claims for an ethical theory of sexed subjects and sexed spaces. Irigaray's theory develops out of her readings of psychoanalysis and philosophy in which the male subject is defined by its difference to other separate entities or objects (or women). In this respect, her writing reflects the

deeply political and ethical concept of the 'Other', which has been developed in feminist and post-structuralist thinking after Simone de Beauvoir's *The Second Sex* and Jacques Derrida's philosophy of 'différance' (e.g. see Grosz 1995, pp. 120–124; 2001, pp. 91–93). However, although Irigaray acknowledges that de Beauvoir actually rejects Irigaray's work (1993b, pp. 9–16), both share a belief that 'otherness' is an essential political strategy for privileging the *different* subjectivities and relationships that traditional structuralist theories overlook.

Table 1 below shows three versions of otherness that define woman in Irigaray's writing. The first two columns situate woman as other within *binary relationships*, where two different values are placed in opposition to each other. In column 1, a *hierarchical* version of this structure is shown in which the terms associated with woman are *always negative*; for example, although woman may have a positive value as a mother, she is nevertheless also associated with incompletion. In column 2, women's qualities of otherness are equal to male characteristics; i.e. each has a *positive* value as part of a *non-hierarchical* binary pair. Finally, column 3 shows a new desirable 'reality' in which women's Otherness is *independent* of binary structures. Here, the sexed subject's unique differences (i.e. her mental and physical powers) are not dependent upon an underlying binary structure (for example, see, 'Any theory of the subject has always been appropriated by the masculine', 1985b, pp. 134–137, and 1985a, pp. 97–101).

1		2	3
Negative hierarchical Unsexed binary		Positive non-hierarchical Sexed binary	Other (non-binary) Sexed subject
Male	Female	Male = Female	Female
Subject	Other	Subject = Object	Subject
Complete	Incomplete	Complete = Incomplete	Incomplete
Original	Imitation	Original = Imitation	Original
Same	Other	Same = Other	Other
Father	Mother	Father = Mother	Mother
Mother (−)	Other	Mother = Other	Daughter
Other (−)	Other	Other = Other	Multiple

Table 1

Irigaray's emphasis on non-hierarchical relationships between subjects underpins her claims for an ethical theory of sexed subjects and sexed spaces.

Binary thinking is a double-edged sword for Irigaray. Overall, it gives her a powerful mechanism of double-thinking through which she identifies the positive and negative values of the female subject. However, binary values also *always* tie the female subject back into a mode of thinking which requires another value (i.e. the male subject) to be present in order for it to be understood. She therefore promotes a third structure, the 'Other' sexed subject which is independent of all binary relations with the male subject. Consequently, there are at least two realities in which a woman's sex can be positively expressed; first, through non-hierarchical dialogues between men and women, and second, through a more radical strategy that reconfigures the sexed relationships into an entirely different reality composed of multiple sexed differences.

For architecture, Irigaray's analysis of Other subjects is a valuable mechanism through which to think about what kinds of subject positions, voices, languages and relationships are allowed or disallowed in architecture; for example, Mary McLeod (Coleman *et al.* 1996, pp. 1–37), and Sarah Wigglesworth (Rüedi *et al.* 1996, pp. 274–287) explore the positive and negative effects of otherness for women architects and users; and Alice T. Friedman (1988) and Lynne Walker (Rendell *et al.* 2000, pp. 258–265) have explored the historical value of women as the 'other' when they are clients or patrons. Questions of access and prohibition of the sexed subject from the histories, politics and social uses of architecture therefore lie at the centre of these discussions.

Speculum touches on the absence of different racial and multi-cultural subjectivities and histories in Western thinking, and her later writings explore alternatives to Western belief systems, such as Buddhism, but Irigaray does not discuss issues of multi-culturalism and race in detail. However, Irigaray's discussions are reflected in the rich desires for political, social and material change that

'Other' (e.g. disabled, gay, Black, Asian, Arab, migrant or transsexual subject positions) sexed subjects bring to architecture. Architectural and spatial examinations of race include; Zeynep Çelik's analysis of Le Corbusier's representation of Algiers (Rendell *et al.* 2000, pp. 321–331); Leslie Naa Nor Lokko's discussion of the Black architect as other (Hill 2001, pp. 175–192), and bell hooks' analysis of multicultural spatial histories (Rendell *et al.* 2000, pp. 203–209). Historians and theorists who have explored gay sexuality or 'queer' spaces in architecture that have also been overlooked by traditional architectural histories and theories, include Patricia White (Colomina 1992, pp. 131–162), Joel Sanders (1996), Henry Urbach (Rüedi *et al.* 1996, pp. 246–263) and Despina Stratigakos (Heynen and Baydar 2005, pp. 145–161). Alternatively, theories and practices of the Other have also recently been developed by artists and architects to critique the physical and legal architectures that are used to control and prohibit economic migrants from crossing the boundaries, showing how prohibition of the 'other' continues to operate in the twenty-first century, for example; Chantal Ackermann's film *From the Other Side* (2002) on the barrier between the US and Mexico, the Atlas Group's research into Lebanon and Multiplicity's project on the Mediterranean: 'ID: A journey through a solid sea' (*Documenta 11: Platform 5* (2002), pp. 14–15, pp. 26–27 and pp. 166–167). Irigaray's ethics of otherness therefore reflects the continuing need to examine and produce real material change in societies so that different sexed subjectivities may be fully expressed in architectural buildings, practice, research and education.

Subjects and objects: subject to subject

Through binary thinking, Irigaray shows that Western ideas of subjectivity are underpinned by positive and negative associations of power. She argues, for example, that binary subject-object relations reflect the unequal power distribution attributed to the positive male subject, versus the inadequate powers of the object or its equivalents (i.e. 'she', 'it' or 'other'). Consequently, the sexed subject is limited to a passive, static material form or 'object' that is dependent upon another's powers (see, for example, her essay, 'Any theory of the "subject" has always been appropriated by the "masculine" ', 1985b, pp. 133–146). In place of these objectifying systems, Irigaray posits the mutually

active exchanges between subjects – 'subject to subject' relationships – that are generated out of the *constantly changing, positive and fluid negotiations between and within different subjectivities*. Sexed spaces of communication are therefore produced out of 'subject to subject' relations that resist linear, uni-directional thinking that underpins subject-object hierarchies, because any 'single' sexed subject embodies a multiplicity of different subject positions, depending upon the relationship he or she has to the other subject.

Instead, the sexed subject's processes of communicating are *dynamic, multi-directional and non-linear*; for example, in the essay, 'The power of discourse', Irigaray describes the importance of the fluid structure of *Speculum*:

> Strictly speaking [it] has no beginning or end. The architectonics of the text, or texts, confounds the linearity of an outline, the teleology of discourse, within which there is no possible place for the 'feminine,' except the traditional place of the repressed, the censured (1985a, p. 68).

Irigaray also subverts the authority attributed to logical or systematic (e.g. rational or scientific) forms of thinking through her disruptive readings of the cultural and etymological origins of language. This is evident in her subversion of the word 'speculum' in the title of her first book, *Speculum of the Other Woman*. Here, Irigaray subverts the medical and cultural values of the speculum (the concave mirror used for internal examinations of women) to show that it is an instrument that places a woman's passive body under the active 'gaze' of the male subject. These specular procedures, she argues, produce scientific 'truths' about women through 'objectifying' procedures, which fix women's bodies into discrete internal and external spaces. Using a metaphorical technique to deconstruct the word 'speculum', she reveals it to be a tool of objectification (making women into 'objects') and distortion that freezes women under the gaze of the male subject. In addition, she subverts the speculum's powers of distortion and reflection to uncover her theory of original sexed subjectivity (Irigaray 1985b, p. 146). Irigaray's rejection of objectifying systems of expression and double-thinking therefore underpins her promotion of active sexed subjects and subject to subject relations, and enables her to undermine the production of discrete determinate objects and systems of thinking.

Multiple realities

For Irigaray, 'reality' – *the way in which a subject lives his or her life* – is always experienced simultaneously on multiple levels. This belief underpins her desire that actual physical, material, political and psychic realities exist for the sexed subject in different historical and spatial contexts in Western culture. As I have suggested above, Irigaray develops some of these ideas in relation to cultural and material understandings of the sexed subject; for example, in the double-play that exists between the sexed subject's physical and psychic experiences, or the manner in which language and institutions construct the sexed subject as positive or negative. Or, by examining how our access to language informs the way in which we can express ourselves in the world, she asks if technical (e.g. architectural), personal, creative, desiring, political, theological and sexed kinds of language are accessible or inaccessible to us, depending upon our sex. These ideas are explored in her examination of the politics of linguistic and disciplinary knowledge in 'Questions' (1985a), for example, or in her discussion of the fragmented 'multiple' subject positions that affect women with mental health issues, in *To Speak Is Never Neutral*.

So the expression of positive *material* sexed difference for women is fundamental to Irigaray's thinking. But she is also concerned with the positive and negative *immaterial* psychic realties which exist for sexed subjects; for example, the construction of woman in myths and stories, or her representation as the repressed unconscious, fantasies, phantasms or as the imagination. So, in addition to exploring the physical sexual desires of women, Irigaray examines how the sexed subject is an inadequate 'imaginary' reality in philosophy or the repressed unconscious in psychoanalysis (1985a, p. 25). Yet, she also shows that woman is a positive immaterial spirit in her essay on non-hierarchical spiritual and mythical sexed realities, 'Fulfilling our humanity' (Irigaray 2004, pp. 186–194), or the 'creation myths' that begin and end the book *To Be Two*. For architectural and urban examinations of the positive and negative affects of women as fantasy see, for example, Elizabeth Wilson's theory of the sphinx in the city (1991); Molly Hankwitz's essay on the work of the artist, Niki de Saint-Phalle (Coleman *et al.* 1996, pp. 161–182); or, Jennifer Bloomer's discussions of

Irigaray's 'gold woman' and the Statue of Liberty (1993, p. 188) and feminine mythologies (Rendell *et al.* 2000, pp. 371–377).

In these later publications, and also in *The Way of Love*, we see a shift in Irigaray's enquiry into Western thinking and the material and immaterial realities it allows or disallows. There is a significant transformation from her earlier highly critical opposition to the limited realities attributed to the sexed subject by philosophy and psychoanalysis (e.g. she is an imaginary imitation or repressed idea), into *dialogues* with philosophers that develop positive discussions about the sexed subject and philosophy (especially in her writing on Heidegger and Levinas). Thus, rather than constructing sexed accounts of motherhood, family, sexual experience or politics for the sexed subject in opposition to dominant forms of Western culture, these later publications develop sexed realities out of positive dialogues with other individual philosophers. This shift is also reflected in a series of inter-related terms that Irigaray develops, such as, 'co-belonging' (2002b, p. 60), 'being-in-relation', 'between-two' and 'in-relation-to-the-other' (2002b, p. 90). So, Irigaray's later work constructs 'another philosophy, in a way a philosophy in the feminine' out of non-hierarchical material and immaterial sexual difference (2002b, p. vii). In Chapter 5 I return to look at these ideas as poetic structures in more detail, but here, Jennifer Bloomer, Catherine Ingraham, Elizabeth Diller and Jane Rendell are examples of architectural practitioners who also engage in creating spaces that demonstrate a commitment to designing and writing sexuate cultures and architectures.

Irigaray's theory of sexual difference and sexed subjects is therefore inherently concerned with positive, multiple, experiences and spaces for living. The *political reality* of the sexed subject in contemporary Western society is intrinsic

Architecture that engages in these ideas is therefore understood as a discipline that builds living sexed cultures, and supports the realities of all sexed subjects.

to her ideas. For Irigaray, specific physical, psychological, biological, sexual, spiritual, historical, and cultural qualities construct the female sexed subject, and in her later writings, the male sexed subject, in their respective worlds. These are important ideas for enabling architecture to express the complexity of sexed societies, and to build real, material and productive realities for all individuals. Architecture that engages in these ideas is therefore understood as a discipline that builds living sexed cultures, and supports the realities of all sexed subjects.

Dialogue

Irigaray's emphasis on dialogue between individuals is reflected in the concluding 'dialogue' sections of each chapter. Here, you are invited to continue each chapter's discussions about the sexed production and occupation of the built environment; for example, by engaging in dialogues with Irigaray's work and the architectural sources referred to here who directly engage with her ideas, or in dialogues about how architectural design, history, theory and criticism reflects her ideas.

How does an architect construct *different* spaces in the architectural drawing, plan and section?

What is *binary thinking* in architectural design? When is it productive? When is it a limitation to design?

What is *multiplicity* in architecture? How does it operate?

What benefits are there in working as *a pair* or a group of designers?

When does architecture encourage the architect to be a *sexed subject*?

How do you develop and structure the production of *multiple* ideas in a group?

What are the *political* implications of the different subject positions that the subject adopts, e.g. the architect as designer and user?

How can an architect use these *different subject positions* to aid his or her work?

Passages and Flows

In the first chapter I argued that Irigaray's fluid 'subject to subject' relations are valuable for architecture because they reconfigure it into irreducible (i.e. infinite) and complex relationships. Irigaray's ideas are also reflected in recent architectural theory and practices that have sought to challenge formalist accounts of architecture that privilege static material spatial organisation. These post-structuralist approaches show that architectural design and its uses are composed of dynamic psychic and material processes which are embodied in the architect, collaborator and user; for example, requiring that the designer develop a flexible range of practical and theoretical aesthetic, social, technical

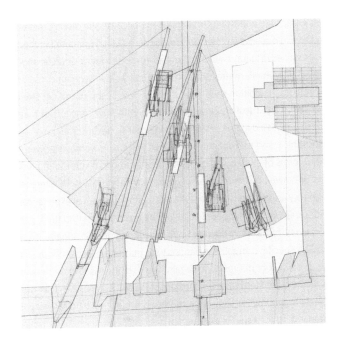

and structural skills. Architectural design, history, theory and criticism therefore become understood as permeable processes through which architecture is built and interpreted.

Certainly, the architectural design profession can be defined by its need to manage and implement large amounts of technical information and materials correctly; especially when such knowledge and skills relate to structural aspects of design, which are legally required to meet statutory regulations. However, in addition to being able to make accurate and precise judgments about the relevant materials, geometries, scales or magnitudes used in the process of designing and fabricating a building, post-structuralist feminist and Marxist architects, historians, theorists and critics have shown the benefits to society and the profession when the architect *also* designs through the negotiation of skills, knowledge and materials, in conjunction with other professionals and with clients.

In this chapter, I suggest that Irigaray's writing about fluid material relationships are important for architecture because she offers practitioners ways to explore how architecture's physical, social and material processes are also sexed. Irigaray's writing retrieves forgotten ideas, sources and 'origins' of women, matter and the sexed spaces that women construct and inhabit. In addition she shows that the sexed subject and her sexed spaces have a particularly close relationship with *fluid* concepts of matter. Irigaray uses this dynamic relationship in order to disrupt traditional philosophical and psychoanalytic theories that ossify women's powers into limited forms of inadequate behaviour. For example, by promoting women's transformative powers of *material production* (especially with reference to pregnancy and childbirth) Irigaray suggests that our spatial experiences and relationships with other people can also be reconfigured into fluid, permeable boundaries, rather than discrete finite spaces. In addition, Irigaray argues that women's specific cultural associations with matter are also embodied in her psychic powers or desires. Once again, she uses the association between woman and her status as an inconstant state of incomplete matter or subjectivity, in order to show that the sexed subject is particularly capable of generating fluid spatial experiences.

Consequently, Irigaray's studies of sexed processes of material and spatial communication can be linked to recent architectural histories, theories and practices of 'fluid architecture', and may enhance discussions about the production of dynamic spaces and social relationships in architectural design. These links are especially clear in her analyses of paths and passageways that highlight the importance of fluid and dynamic spaces of communication, and in her examination of the sexed subject's physical and psychological experiences of 'dwelling'.

The cave and passage

In *Speculum* Irigaray argues that women's ability to construct positive material spaces has been forgotten by Western philosophy. In a long essay called 'Plato's Hystera' she analyses one of Plato's canonical philosophical texts, *The Republic*, which contains a mythical story about the Gods, human subjects and the cave in which humans dwell. Plato's dialogue is considered to be significant because it describes the 'origins' of different kinds of knowledge, within a spatial representation. Plato describes how two realities exist. First, the Gods, and hence divine or transcendental ideas, are located outside the cave. By contrast, a second reality exists inside the cave, which is composed of empirical human matter (i.e. bodily experiences). Irigaray shows, however, that women's relationship to dwelling, matter and space are misrepresented by this influential account of Western thinking and forms of representation. First, she observes that the cave can only be a material imitation of divine and unknowable ideas. Moreover, she argues that, not only are the cave and its occupants mere representations or 'reflections' of an unknowable original realm (i.e. they are not 'real' experiences), but they also exclude the presence and experiences of women.

For Irigaray, this amounts to the exclusion of the sexed subject and sexed space from Platonic philosophy. First, she shows that if women are present in this story, they are limited to *phantasms, imitations* or *reflections* of male subjects; for example, they are the 'shadows' of men on the wall of the cave. Second, she argues that Plato ignores that the cave is analogous to the physical shape of the womb (the *hystera*) so that the sexed origins of human spaces of dwelling are

forgotten (1985b, p. 243). Drawing out this analogy, she also shows how Plato consigns the cave to a *passive* 'ground' or space that supports male activity, again further ignoring its association with the womb, the *active* sexed place from which human subjects are actually produced (1985b, p. 244). Thus, for Irigaray, Plato's story is a creation myth about the origins of human culture, but at the expense of women's role in the actual formation of sexed subjects and sexed spaces.

Irigaray's analysis is also developed through her multiple cultural and etymological readings of the ancient Greek vocabulary for womb (*hystera*), mother (*matrix*) and matter (also, *matrix*). These readings underpin her argument that woman is relegated to the passive position of a supporting ground or dwelling for men's activities inside the cave. Irigaray's examination of these multiple layers of interpretation reveals that woman and her powers of production are relegated into a series of supporting roles. Once again, the shape of a woman's reproductive organ (the womb or *hystera*) is merely a formal analogy of the space of the cave, so that woman is consigned an imitation or equivalent space of production. Finally, Irigaray argues that woman's value as a passive spatial matrix (matter/mother) emphasises, even more firmly, that she is a second-rate material production of the world, not a pure abstract idea. Consequently, Plato's origin myth relegates woman to a secondary, supporting and material role in the production of the human subject.

Irigaray then develops this critical analysis of the cave and the *hystera* to show that Plato also overlooks the importance of the 'passage' or the birth canal (a second connected sexed space) in the production of the sexed subject. In a section called, 'A one-way passage', she argues that, although Plato's myth of the origin of human subjectivity values the mother as an analogue of spaces of production, he fails to recognise the special powers of transformation embodied in the feminine 'Forgotten path' that lies between a subject's biological beginnings and his or her social life:

> But there is also *a path*, no doubt made in the image of the conduit, neck, passage, corridor which goes up (or rather would go down) out of the cave toward the light of day, toward the sight of the day. Gallery, sheath,

envelope-passage, enveloped, going from the daylight to the underground grotto and its fire. A conduit which is taken up and reproduced *inside* the cave. A repetition, representation, figuration re-enacted within the cave of that passage which we are told leads in and out of it. Of the path *in between*. Of the 'go-between' path that links two 'worlds', two modes, two methods, two measures of replicating, representing, viewing, in particular the sun, the fire, the light, the 'objects,' and the cave. Of this passage that is neither outside nor inside, that is between the way out and the way in, between access and aggress. This is a key passage, even when it is neglected, or even especially when it is neglected, for when the passage is forgotten, by the very fact of its being re-enacted *in* the cave, it will [. . .] sustain the hardening of all dichotomies [. . .]. But what has been forgotten in all these oppositions, and with good reason, is how to pass through the passage, how to negotiate it – the forgotten transition [. . .] (1985b, pp. 246–247).

For Irigaray, Plato's story therefore fixes women's productive role into a minor order of imitation, reflection and derivatives. In addition, she argues that in his forgetting of the hystera, he also overlooks the sexed origin of passages, pathways or 'in-between' spaces, which link space with time in the movement between interior and exterior spaces. Alternatively, when he does admit the existence of the passage, its power of material transformation is lost because it is an imitation of the idea of the cave, thereby further emphasising the *inadequate representation* of woman's powers for generating *actual original* physical and intellectual transformation.

In contrast, Irigaray reinterprets the cave and passage as dynamic, multiple sexed spaces of positive material and fluid transformation, and her critique connects with arguments made by feminist architects, such as Sarah Wigglesworth and Frances Bradshaw/Matrix, and architectural theorists such as Kanes Weisman (1992, pp. 149–159) and Hayden (1984, pp. 173–208), who have argued that positive experiences of childcare and family life are constructed out of passageways and fluid, open spaces that enable communication and physical interaction *between* all subjects. Alternatively, Jane Rendell links together Irigaray and Walter Benjamin's theories of passages, thresholds and boundaries in her study of the Burlington Arcade (Coles 1999, pp. 168–191). Below I

describe how Irigaray's theory of fluid matter is also reflected in architectural explorations of intimate fluid interaction between subjects.

Fluid matter

Irigaray's examination of the relationship between woman and matter is also significant for understanding how sexual difference is embodied in the sexed subject and sexed spaces. In *Speculum* she argues that matter is a necessary constituent of traditional metaphysics; however, it is also always conceived as secondary to pure unchanging forms and ideas. Matter is inadequate because it embodies change, diversity and local difference, not pure, universal and constant ideas or origins. In addition, according to these hierarchies, men are associated with rational ideas and women are associated with matter, leading Irigaray to argue that women are considered to be inadequate physical *reproductions* of men's intellects. She demonstrates that ideas about the material expression of the world construct damaging binary differences between men and ideas, versus women and matter, which also underpin the relationships between idea/object, form/matter, immaterial/material, mental/physical, space/time, being/becoming, science/art, general/particular and finitude/infinity. In contrast, she argues that women embody *active* material processes through which they originate particularly positive *productions* of reality; for example, a woman's unique role in childbirth, the expression of her sexual desires, or the importance that women place on inter-subjective emotional relationships. Each of these feminine experiences constitutes positive and productive understanding about the material powers of the sexed subject. Matter, then, for Irigaray, is a concept through which she rethinks sexed physical and social relationships in modern society.

So, Irigaray believes that Western thinking has tended to assign particularly negative material qualities to woman; for example, she is associated with unoriginal imitation, repetition or simulation of material space, and she has been described as a vessel, container or volume, which is passive until it is used or activated by another (male) agent. Also, paradoxically, woman has been aligned with ideas of incompletion, infinity and formlessness, because of her unstable physical fluid powers that are derived from her excessive sensory or material drives, rather than 'pure' intellectual ideas or 'reason'. Woman is

therefore an inherently contradictory (i.e. dialectical) matter, and Irigaray shows that these associations undermine the value that is placed on her actual creative contribution to culture and society. Moreover, she argues that a woman's productive powers are original precisely because they are embedded in her

Matter, then, for Irigaray, is a concept through which she rethinks sexed physical and social relationships in modern society.

material fluidity. By challenging theories of 'inadequate' contradiction, Irigaray shows that woman constitutes an entirely different kind of matter that is intrinsically concerned with movement, time, fluidity, flow and the actual material transformation of space. Below, I explore how Irigaray's ideas produce positive understandings of the physical materials, psychological flows and passages within and between different spaces and desiring individuals. In addition, her ideas engage with recent architectural design, history, theory and criticism that promote fluid material practices and sexed spaces.

In the essay, 'Volume without contours', translated as 'Volume-fluidity' in *Speculum* (1985b), Irigaray examines the positive nature of woman's powers of material and psychic transformation. Here, she promotes the *productive* material origins of birth and gestation as examples of the sexed subject's origination of the sexed spaces, in contrast to the passive role philosophy and psychoanalysis assign to women's acts of re-production or imitation. Irigaray connects the multiple psychic powers of woman to the dynamic materialisation of sexed subjectivity in pregnancy and birth, for example, writing:

> *The/A woman is never closed/shut (up) in one volume.* That this representation is inescapable for the figure of the mother makes us forget that the woman can become all the more fluid in that she is *also* pregnant/enclosed [*enceinte*], in that, unless the womb is reduced – by him, by him in her – in phallic appropriation, it does not seal up the opening [*écart*] of the lips (1991b, p. 65).

The origins of active, material spatial experiences are therefore present in the irreducible and paradoxical image of the womb, which is a *dynamic place* in the sexed subject, not a discrete disconnected container. In addition, Irigaray generates a different 'original' place of production out of the dynamic and permeable movement between the internal and external spaces of a woman's body. As a result, women's physical and psychic powers are understood as mutually active sources of differentiation in the sexed subject (1991b, pp. 45–46). (In the next chapter, I also explore this material continuity in the *tactile* exchanges and relationship between the foetus and the mother, which also reflect the fluidity of psychic and physical relationships).

In essays such as, 'The "mechanics" of fluids', Irigaray also examines how woman's fluid psycho-biology is misrepresented by psychoanalytic theory because it ignores her original fluid properties (especially her blood and milk). She writes, for example; 'Now if we examine the properties of fluids, we note that this "real" may well include, and in a large measure, a physical reality that continues to resist adequate symbolisation' (1985a, p. 106). Later, in the book, *Marine Lover: Of Friedrich Nietzsche*, she analyses Nietzsche's poetic text, *Thus Spake Zarathustra* (1885), to develop a powerful image of dynamic feminine matter out of woman's fluid subjectivity and the 'creative' power of the sea. In this essay she analyses Nietzsche's theories of origin and difference through poetic passages (i.e. paragraphs) that explore the irreducible movement and depth of the 'feminine' sea as it ebbs and flows:

> In me everything is already flowing and you flow along too if you only stop minding such unaccustomed motion, and its song. [. . .] So remember the liquid ground. And taste the saliva in your mouth also – notice her familiar presence during your silence, how she is forgotten when you speak. Or again: how you stop speaking when you drink. And how necessary all of that is for you! These fluids softly mark the time [. . .] (1991a, p. 37).

Irigaray's productive exchange with philosophers is also evident in her poetic analysis of Heidegger's philosophy in *The Forgetting of Air: In Martin Heidegger* (1999). Each book is an encounter that *builds positive fluid* and *feminine paths* out of the exchange, and marks a distinct shift from her earlier critical readings

of philosophy in *Speculum* and *This Sex*. Challenging theories of matter and space that reduce woman to formless, passive, inert or inadequate material reproductions, these critiques of the origins of Western thinking enable her to reconfigure the relationship between the sexed subject and theories of fluid matter. As a result, sexed spaces of feminine passages and paths are retrieved that undermine the binary opposition between unsexed intellectual ideas and sexed material bodies and spaces.

Furthermore, Irigaray shows that material powers of transformation and production are intrinsic to the *desiring* female body, particularly with respect to childbirth, which produces new definitions of an active, intelligent and sensing matter. For architecture, these are interesting tactics through which to rethink formalist theories of space that consider matter to be formless until it is shaped and activated by the application of an external idea or form. In architectural design, for example, Susana Torre's design for a house in Santo Domingo (1972–1973), explores the social benefits of fluid spaces in housing (Kanes Weisman 1992, p. 153). Other recent projects by women architects exploring fluid spatial organisation include Caroline Bos and Ben van Berkel's 'Moebius House' (1998), and Alison Brooks Architects' 'Wrap House' (2004–2005), which weave together the working, social and private spaces of the house to form architectures that allow for fluid exchange. In addition, theoretical arguments about the fluidity of architectural matter are present in: Elizabeth Grosz's examination of Irigaray's idea of 'excess' (2001, pp. 150–161); Katie Lloyd Thomas's essay on architectural matter (2007, pp. 2–12); Beatriz Colomina's essay on Loos and Le Corbusier (1992, pp. 73–130); or when Adrian Forty challenges the association between masculine forms of modernism and fluid architectures, making reference to Neil Denari's folded architecture that is 'pliable' like feminine spaces (Rüedi *et al.* 1996, p. 153).

Desire, jouissance and love

Concepts of desire pervade the history of Western thought, and these ideas are also significant for Irigaray's theories of space and for architecture, because they enable the negotiation of the threshold between physical and psychic states of existence; for example, in the divide between the intellectual realm of

immaterial ideas and concepts, versus the sensory realm of embodied emotions, feelings and perceptions of the world.

In Descartes and Spinoza's seventeenth-century writings, desire is located in the 'passions' (i.e. emotions) of the human subject. Alternatively, in Freud's nineteenth-century thought, desire is associated with the psycho-sexual 'drives' or urges. For Marx, the production of capital reflects desire's power of material transformation. In each theory, therefore, desire is a power that is embodied in the subject's thoughts *and* feelings. However, Irigaray shows that traditional philosophy has not developed a sustainable and positive theory of desire for women. In *Speculum* and *This Sex* she examines desire in order to show how philosophy and psychoanalysis have misinterpreted the relationship between desire and the sexed subject, to the detriment of women's lives. In particular, she argues that these disciplines have tended to develop the relationship through negative connotations of lack or excess and irrationality (e.g. by defining woman's emotions as irrational).

In the context of architecture and urban space, Walter Benjamin's *The Arcades Project* (1927–1940), Louis Aragon's *Paris Peasant* (1926), Henri Lefebvre's *Critique of Everyday Life* (1947), Michel de Certeau's *The Practice of Everyday Life* (1974), Guy Debord's *The Society of the Spectacle* (1967) and Rem Koolhaas's *Delirious New York* (1994), have also explored the relationship between the individual subject, his or her desires and the modern city, showing it to be comprised of irreducible material drives and aspirations. More recently, architectural and feminist historians and theorists have developed examinations of desiring and desired women who walk and reconfigure the spaces of the city, and reflect Irigaray's analyses of desire; for example, Wilson's *The Sphinx in the City*, Rendell's *The Pursuit of Pleasure* and Morris's examination of gendered desire in shopping malls (Colomina 1992, pp. 168–181).

Irigaray promotes a highly productive kind of desire that is derived specifically from the sexed subject, especially in *An Ethics of Sexual Difference*, *Marine Lover* and *The Way of Love*. This desire is positive, ethical and non-hierarchical, and does *not* exclude intellectual thinking. It is an extremely important idea in her writing because it represents a key form of corporeal energy, agency or

power in the sexed subject, and its qualities are reflected in a number of other post-structuralist philosophical critiques by Deleuze and Guattari, Foucault, Derrida, Lyotard, Cixous and Kristeva. In contrast to psychoanalysis's definition of feminine desire as a lack of satisfaction or coherence in the individual or system, or philosophy's definition of sexed subjects as excessive and incomplete states of subjectivity, each of these post-structuralist examinations of desire defines it as a positive *act of material transformation*, not just a theoretical idea.

In addition, Irigaray, Cixous and Kristeva also explore a specifically feminine form of sexual desire and pleasure called *jouissance* which generates the irreducible powers of the sexed subject. These discussions feature strongly in Irigaray's publications, *This Sex Which Is Not One* (1985a), and *An Ethics of Sexual Difference* (1993a). For example, in the essay, 'This Sex', woman's desire is plural, not restricted to a single point of origin; 'woman has sex organs more or less everywhere' (1985a, p. 28). Alternatively, in the essay, 'When our lips speak together', Irigaray explores the space for desire that is expressed in women's speech, and in the sexual act of kissing:

> **And the passage from the inside out, from the outside in, the passage between us, is limitless. Without end. [. . .] Are we satisfied? Yes, if that means we are never finished. If our pleasure consists in moving, being moved, endlessly. Always in motion: openness is never spent nor sated (1985a, p. 210).**

In addition to these essays exploring sexual desire between women, Irigaray's writing after the mid 1980s reveals a more generous account of modern Western philosophy's concepts of 'desire', for example in her examination of the forgotten routes to pleasure in Descartes' writing. In the essay, 'Wonder', she writes that Freud's theory of the subject's psychosexual drives actually forgets Descartes' earlier seventeenth-century theory of the passions, whereas Descartes

> **constructs a theory of the ego's affects which is close to Freud's theory of the drives. He does not differentiate the drives according to the sexes.**

> Instead, he situates wonder as the first of the passions. Is this the passion
> that Freud forgot? A passion that maintains a path between physics and
> metaphysics, corporeal impressions and movements towards an object,
> whether empirical or transcendental. A primary passion and a perpetual
> crossroads between earth and sky, or hell, where it would be possible to
> rework the attraction between those who differ, especially sexually
> (1993a, p. 80).

Here, Irigaray grants Descartes' passions the ability to *embody* a *route* or a
path between the corporeal powers of the subject and the divine realm,
constituting a transcendental or metaphysical form of desire. Nevertheless,
she concludes that Descartes only allows the relationship between the divine
transcendental and the material human realms to exist for men, not women.
Later, however, in *I Love To You* and 'The fecundity of the caress' (1993a),
she re-engages with philosophical thinking in a series of studies of intimate
desiring and loving relationships. In these essays she emphasises the
importance of intimate and physical spatial relationships that do not depend
upon a total 'mastery' or desire of the other subject, but are developed out of
absolute difference between subjects; for example, in her analysis of Levinas'
notion of the 'caress' she identifies a different *path* through which love is
generated between two subjects, writing:

> The evanescence of the caress opens on a future that differs from an
> approach to the other's skin here and now [. . .] There, every subject loses
> its mastery and method. The path has been neither made nor marked, unless
> in the call to a more distant future that is offered by and to the other in the
> abandonment of self. Causing the possibles to recede, thanks to an intimacy
> that keeps unfolding itself more and more, opening and reopening the
> pathway to the mystery of the other (1993a, pp. 188–189).

Thus, throughout Irigaray's analyses of desire and love that are generated by
sexed subjects, she describes the importance of a spatial distance, resistance or
dialogue between subjects, not an idea of desire that entirely consumes the
other's boundaries. Alternatively, in her discussion of Heidegger's theories of
subjectivity in *The Way of Love* she describes her engagement with his ideas as

'a loving encounter, particularly an encounter able to dialogue in difference' (2002b, p. xvii). Thus, rather than focusing on intellectual endeavour that is developed out of a purely dematerialised notion of desire, Irigaray shows that critical and creative realities, and thinking processes, are produced out of dynamic social encounters and spaces that originate from the material powers of fluid desire or love.

. . . she describes the importance of a spatial distance, resistance or dialogue between subjects, not an idea of desire that entirely consumes the other's boundaries.

For the architectural designer, Irigaray's theories of fluid, desiring thinking therefore offer stimulating and energetic paths and passageways through which to explore the value of dynamic spaces for developing creative architecture and its use today and in the future. Architectural designers, historians and theorists have examined desire to reveal how architectural space is gendered, and how feminine desire constructs intimate interiors; for example, Vanessa Chase explores novelist Edith Wharton's decorative and gendered home (Coleman *et al.* 1996, pp. 130–160) and Anne Troutman examines the erotic feminine intimacy of the boudoir (Heynen and Baydar 2005, pp. 296–314). Alternatively, the editors' introduction to *Desiring Practices* highlights the importance of desire for positively rethinking creative and political architectural practice. Below, I provide some questions that you may also wish to explore, in relation to Irigaray's ideas and the architectural examples that I have outlined in this chapter.

Dialogue

How can designers create *paths* or *passages* to enable communication between individuals in modern buildings?

How can designers help the people who work in their buildings *modify or adapt* the objects/environments in which they work?

How do *personal relationships* affect the way in which the architectural profession has developed, and construct how we use domestic and private spaces?

What are the positive aspects of *feminine spaces* in architecture?

How do domestic spaces enable people to live in *'fluid'* ways?

What positive and negative *desires* operate in architectural design?

Touching and Sensing

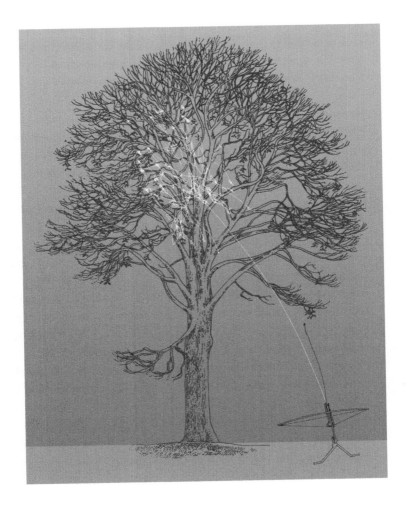

Irigaray's writing shows that spatial relationships between subjects and their environments are also constructed through sensory perception (especially touch); for example, in the intimate encounters or dialogues between embodied subjects. In addition, Irigaray's theory of the *sensory* sexed subject challenges the importance placed on the autonomous, self-determining and seeing subject in Western thinking. Instead, by examining philosophical debates about the powers of the intellect (i.e. the mind) and the senses (i.e. the body), Irigaray proposes a new positive 'economy' of touch and sensation which is created through shared intimate spatial relationships and histories. Furthermore, the privilege she gives to sense-based modes of spatial and social interaction is also reflected in recent architectural design, history, theory and criticism that promote the subject's sensory interaction with his or her environment.

For the architect, Irigaray's theory of sensing subjects and spaces provides an interesting discussion through which to explore the importance of sense-based interaction with architectural design. In this respect, her ideas are reflected in: contemporary design, history and theory research into the sonic, tactile and olfactory experience of architectural materials and space that augment the immersive qualities of an architectural experience (e.g. in acoustic design and therapeutic applications); or in the development of 'dynamic' materials (e.g. heat-responsive plastics and membranes) and 'reflexive' architectures that respond to the needs of the user and the environment (e.g. Kas Oosterhuis and Lars Spuybroek's designs, and Neil Spiller's theory). In addition, architectural history and theory has re-evaluated the sense-based spatial interaction brought about through touch and sound in modern architecture (e.g. see Hill (ed.), *The Subject is Matter*, 2001, or Pallasmaa's *The Eyes of the Skin*, 2005), challenging modernist theorisations which limit it to a visual experience. Accordingly, architectural design, history, theory and criticism are situated into an expanded field of multi-sensory exploration that promotes the importance of the active subject or user.

Spatial sensitivity is integral to the role of the architect and the user, and Irigaray's ideas about the importance of the sensing and sexed subject may also provide valuable ideas to the debates. Furthermore, she provides a richer

understanding of how space and subjects relate to each other than some of the universal claims for *unsexed* sensory space made by architects, such as Pallasmaa, because each is developed out of sexed understandings of the senses. Also, unlike architectural theories that suggest sense-based experiences of architecture depend entirely upon the new technical developments in interactive design, Irigaray shows that sense-based experiences have always existed, but have been forgotten by Western traditions of technology and visual culture. Her writing therefore helps to challenge the hierarchy drawn between intellectual, abstract and immaterial forms of knowledge, versus the unstable and material images, ideas, spaces or relationships that are constructed through our senses. As a result, her theory of sense-based spatial experience, intimacy and intersubjective relations may also enable architectural designers, historians, theorists and critics to retrieve overlooked material and social histories of architecture, and to develop new sense-based practices.

Self-touch

For Irigaray, the question of how to get back 'in touch' with a more meaningful understanding of the sexed subject and sexed spaces is one of the most important discussions about the senses in her work. In her early writings (e.g. *Speculum*, *This Sex*, *An Ethics of Sexual Difference*, and *The Irigaray Reader*) this enquiry is specifically directed at examining the ways in which philosophy and psychoanalysis have misdirected the production of knowledge by forgetting the sexed subject or woman. Thus, Irigaray's arguments about 'self-touch' are political because they promote the need to rethink the sexed subject's histories and 'origins' (and to create new sense-based cultures for women and men). For Irigaray, however, a self-touching subject is primarily associated with the *active* thinking woman, who is informed of the hidden and repressed accounts of women's sensory powers in Western thought; for example, in 'Volume without contours' she writes:

> This (self-)touching giving woman a form which is in(de)finitely
> transformed without closing up on her appropriation. Metamorphoses
> where no whole [*ensemble*] ever consists, where the systematicity of the One

never insists. Transformations, always unpredictable because they do not work towards the accomplishment of a *telos* which would imply one figure taking over – from – the previous figure and prescribing the next: *one* form arrested, therefore, and becoming *another*' (1991b, p. 59).

Moreover, Irigaray's figure of 'self-touch' refers to the way in which women physically and psychically interact with the world without being dependent upon another's presence or ideas. If we recall her definition of sexual difference in Chapter 1, for example, a woman's 'sex' enables her to touch – i.e. activate – herself physically. In addition, Irigaray suggests that this ability to self-touch is an original source of psychic activity or desire. This metaphor of physical and psychic 'contiguity' therefore enables Irigaray to undermine 'instrumental' forms of knowledge which construct passive bodies that can only be activated through the application of a rational active mind; for example, in *This Sex*, she writes:

> In order to touch himself, man needs an instrument: his hand, a woman's body, language . . . And this self-caressing requires at least a minimum of activity. As for woman, she touches herself in and of herself without any need for mediation, and before there is any way to distinguish activity from passivity. Woman 'touches herself' all the time, and moreover no one can forbid her to do so, for her genitals are formed of two lips in continuous contact. Thus, within herself, she is already two – but not divisible into one(s) – that caress each other (1985a, p. 24).

The sexed subject and her powers of tactile expression produce original cultural, social and physical interaction between people and spaces. Once again, Irigaray's double-thinking is central to her theory of touch and its embodiment in the *active* physical and psychic interactions that are generated between the sexed subject and her environment. Being 'in touch with oneself' supports Irigaray's argument that desire, which is constructed out of touch, prevents the sexed subject's intellectual experience of the world from controlling the spatial and social experiences of another person. Furthermore, Irigaray promotes touch over vision in order to resist being drawn back into the history of Western

discourse (reason) which, she argues, controls, consumes or appropriates an idea, another person or object. Rather, she shows that thinking through touch is a new 'style' of *expression* for describing the sexed subject's interactions with other people, and understandings of materials and spaces. In the interview, 'The power of discourse', she argues that:

> This 'style' does not privilege sight: instead, it takes each figure back to its source, which is among other things tactile. It comes back in touch with itself in that origin without ever constituting in it, constituting itself in it, as some sort of unity. Simultaneity is its 'proper' aspect – a proper(ty) that is never fixed in the possible identity-to-self of some form or other. It is always fluid, without neglecting the characteristics of fluids that are difficult to idealize: those rubbings between two infinitely near neighbours that create a dynamics (1985a, p. 79).

In addition, because the self-touching subject is always 'in touch' with her own origins, histories, feelings, materials or spaces, and because her physical and psychic relationships are conducted through tactile contact, rather than visual capture, she is opposed to the covetous desires of the single subject. For Irigaray, the subject's sense-based consciousness of different social, political and historical origins therefore enables unequivocal respect for the 'Other' to be established. Intimate relations develop between subjects (i.e. subject to subject relations) that resist the separation of discrete bodies into separate realms of closed and fixed ideas. Touching constructs the importance of relations *between* subjects, for example, in the activities of nurturing and loving in intimate relations that occur between mothers and their children. Once again, Irigaray develops these discussions in order to challenge the definition of the subject on the basis of singularity and autonomy. Rather, specific social and physical relationships, and spaces, are constructed that are both physical and psychic sensory experiences.

Therefore, for Irigaray, a new theory of the sexed subject and her powers of expression is possible once she is put back 'in touch' with her origins. In addition, these sensory bodies, spaces and knowledges are important because they are generated out of multiple social relations and subjectivities; first,

because each subject is already composed of multiple physical and psychic sensations, and secondly, because 'to touch' situates the subject *in relation to* her own and another's environment, further underpinning Irigaray's belief that the subject is uniquely differentiated, yet is also *always* connected to the world in which he or she exists.

. . . these sensory bodies, spaces and knowledges are important because they are generated out of multiple social relations and subjectivities . . .

In the past 30 years, architectural historians have written accounts of women working in the profession since the eighteenth and nineteenth centuries, enabling architects and students to get 'in touch' with their ideas, designs and buildings, including; Doris Cole's history of women in architecture, *From Tipi to Skyscraper* (1973); Sara Boutelle's work on the early twentieth-century architect, Julia Morgan (Torre 1977, pp. 79–87); Peter Adams' book on Eileen Gray (1987), and Beatriz Colomina's essay on Gray's house E.1027 in Roquebrune, Cap Martin (Hughes 1996, pp. 2–25). Lynne Walker has written about sisters Jane and Mary Parminter who designed a house A-la-Ronde (1794), together with a chapel, school and almshouses in the eighteenth century; nineteenth-century women who worked as designers in architecture, such as Harriet Martineau, Agnes and Rhoda Garrett, Ethel and Bessie Charles and Elisabeth Scott; and the increasing contribution of women in the discipline in the twentieth century (Rendell *et al.* 2000, pp. 244–257). Alternatively, Alice T. Friedman has written about the creative patronage of Frank Lloyd Wright by clients Aline Barnsdall and Alice Millard who significantly contributed to his development of innovative Californian houses (1998), and Flora Samuel has argued that Le Corbusier's collaborations with Charlotte Perriand, Eileen Gray and Jane Drew need to be re-evaluated (2004).

Skin, bodies together and caresses

Irigaray's interest in touch also enables her to explore its importance for the sexed subject's material and bodily interactions with other people. Unlike the

emphasis on intellectual and projective powers of production that are associated with vision, the power of touch underpins Irigaray's analysis of social relations and spaces that are developed out of dynamic material properties. As a result, sensory experiences of the world, space and architecture are generated out of tactile and non-verbal relations; for example, the intimate physical experiences of skin-to-skin and body-to-body relations, such as childbirth and sexual relationships. In this respect, fluid differentiations of space, and the potential for continuous material transformations of spaces, are also valuable ideas for architectural design, history, theory and criticism that prioritise the tactile experience of positive body-to-body relations.

In the essay 'Love of the other', Irigaray points to the deficient 'partial sexuality' of unsexed material spaces. In these systems and architectures, Irigaray writes that 'rational' modes of organisation are prioritised and 'the body is cut into parts like a mechanical body. Energy is equated with work energy. This is no doubt part and parcel of our era [. . .] but, for all its apparent progressiveness, it forgets or shuns the flesh' (1993a, p. 143). She continues her critique of the mechanical, intellectual body to show that it is also reliant upon technical means of production that are, in turn, reflected in the spaces that it produces; 'Man has built himself a world that is largely uninhabitable. A world in his image? An uninhabitable functional body? Like the technical world and all its sciences. Or like the scientific world and all its techniques.' So, for all its technical efficiency and progress, Irigaray argues that the construction of the modern ('Cartesian', i.e. after Descartes) body reflects mechanical and instrumental relationships. In texts, such as, 'Place, interval: a reading of Aristotle, *Physics IV*' (1993a), *Marine Lover: Of Friedrich Nietzsche* (1991a) and *To Be Two*, by contrast, she proposes a sense-based definition of the sexed subject that is not mechanical or instrumentalist.

As before, these essays play a double game of revealing the 'underbelly' of unsexed ideas, subjects and spaces, as well as suggesting that a *different* economy of sexed spaces and relations simultaneously exists. By examining Aristotle's construction of woman as 'place' or time in the essay, 'Place, interval', for example, she shows that Aristotle's association between woman, place and time is dependent upon an inadequate idea of the sexed subject's powers of

touch. Yet the discussion also enables her to show the originality of a woman's specific experiences of time and intimate material spaces in the 'place' of childbirth. Thus, in her criticism of the limits that Aristotle puts on the material and tactile boundaries between the foetus and mother she also reveals a different *permeable* notion of intersubjectivity that exists in the physical and psychic intertwining between mother and child:

> Can this be understood of the *body* and in its relation to the skin? In a different way from the *foetus* in its relation with the first enveloping membranes and the umbilical cord. Even though the foetus is a continuum with the body it is in, even though it passes from a certain kind of continuity to another through the mediation of fluids: blood, milk [. . .] (1993a, p. 46).

However, we should also be careful to note that Irigaray's affirmation of the particularly permeable spaces of pregnancy do not exclusively restrict the sexed subject to this one experience of social relations; that is, she does not define all touch or all subjectivities on the basis that the sexed subject is always a mother. Rather, she reveals a specifically sexed source through which *all* subjects are developed (and, until pregnancy is an option for men, or can be supported artificially entirely outside a mother's body, this is still an experience that all men and women still share). Alternatively, in the essays, 'This sex which is not one', 'Volume without contours' and the essay, 'Veiled lips' in *Marine Lover*, she shows that absolute divisions between internal and external space are removed in the sexed subject's expressions and in the internal *and* external contiguity of her body;

> Always moving inside and outside at the same time [. . .] According to at least four dimensions: from left to right, from right to left, from before after, from after before, the threshold of the inside to the outside of the body. [. . .] Thus is ceaselessly engendered the expansion of her 'world' that does not develop within any square or circle or. . . and remains without limit or boundary (1991a, p. 115).

In addition, because the sensation of touch is not limited to one single sense organ or action, the production of limited, defined space is resisted. Tactile or

haptic space is highly developed in this exchange, in distinction to definitions of space which limit it to quantitative intellectual representations of boundaries and volumes, insides and outsides (and, in the next chapter, I explore Irigaray's rethinking of topological space in more detail).

Alternatively, in the last two essays of *An Ethics of Sexual Difference*, Irigaray engages with the work of two philosophers who have developed theories of touch; Merleau-Ponty's early writing on a 'tactile' form of vision, and Levinas' theory of the 'caress'. In her first essay, 'Invisible of the flesh', Irigaray explores the missed potential of touch in Merleau-Ponty's argument about subject and object relations. She criticises his attempt to develop a theory of sense-based interaction between subjects and objects merely out of vision. However, in doing so, Irigaray also uncovers the potential for a tactile mode of expression (that Merleau-Ponty is unaware of) but which is evidence of the sexed subject's powers of touch:

> Here, Merleau-Ponty makes flesh go over to the realm of things and as if to their place of emergence, their prenatal ground, their nourishing soil [. . .] Indefinitely, he has exchanged seer and visible, touching and tangible, 'subject' and 'things' in an alternation, a fluctuation that would take place in a milieu that makes possible their passage from one or the other 'side'. An archaic fleshly atmosphere, a sojourn that it is difficult not to compare once again to the intrauterine or to the still barely differentiated symbiosis of infancy (1993a, p. 159).

In the final essay of the book, 'The fecundity of the caress', Irigaray engages more positively with a philosopher of touch. In this examination of Levinas' philosophy of love, she acknowledges that his theory of the caress produces a particularly tactile form of interaction between two people. Irigaray applauds Levinas' emphasis on the ethical need for alterity (i.e. absolute, unknowable difference) in another person which also reflects Levinas' Jewish identity and scholarship, and his critique of Western thinking. However, Irigaray's interpretation remains critical because, although she supports Levinas' examination of love and ethical relationships, she argues that he too fails to actualise their full potential because the sexed subject is prevented from fully

expressing herself in the process. She concludes that Levinas' caress is both a divine and material experience for men, but can only be material for women, who are prevented from progressing from intimate human relations to the divine potential of love. Thus, once more, the sexed subject's productive powers of touch are taken into account, but ultimately, Levinas restricts them to a material and transitional encounter (1993a, p. 186).

In the later publication, *To Be Two* (2001b), Irigaray returns again to her analyses of Merleau-Ponty and Levinas, together with an examination of Sartre's theory of the subject. Here, she examines each philosopher's attempts to generate a 'sexuate body'. However, she argues that, in each case, the construction of desire, perception or love that is developed is inadequate for a truly sexed subject. Thus, Irigaray concludes that philosophy contains discussions of the intimate, desiring body, but that its concepts of perception, sense and love are dependent upon the neutralising affects of unsexed ideas. She criticises Merleau-Ponty's concept of perception for merely developing a theory of vagueness, 'indeterminacy' and passive feeling, writing, for example; 'Merleau-Ponty's text shows that we lack a culture of perception and, because of this flaw, we fall back into the realm of simple feeling' (2001b, p. 23). Or, in her criticism that Levinas' theory of intersubjectivity (i.e. the interaction between two people) recognises the feminine subject, but reduces woman to an 'equivocation' of the male subject. Nevertheless, Irigaray also draws out of these discussions her own theory of the sexed caress that establishes specific, differentiated histories and spaces of inter-subjectivity; for example, she constructs sexed modes of social and personal relations through the metaphor of the 'caress'. It is a 'gesture-word', she writes:

> [which] has nothing to do with ensnarement, possession or submission of the freedom of the other who fascinates me in his body. Instead, it becomes an offering of consciousness, a gift of intention and of word addressed to the concrete presence of the other, to his natural and historical particularities (2001b, p. 26).

Here, therefore, a significant change in Irigaray's language can be seen whereby the male sexed subject is embraced within the female sexed subject's world.

Rather than excluding or opposing the male subject, Irigaray shifts the tone of her encounter so that male subjectivity is also reconfigured in the relationships. In the next section, I explore this shift from negative to positive intimacies and relationships, or dialogues and spaces of exchange, that engage with the other's historical and social specificity. First, however, examples of architectural and spatial practices which have also explored these themes of permeability, inter-subjective boundaries and contiguous relations between inside and outside spaces include: projects by designers Fiona Raby and Tony Dunne, who have explored sonic design and 'leaky' urban projects, including a 'touch tone architectural interface' in which the user releases acoustic experiences in a building through touch (e.g. Dunne's *Hertzian Tales*, 2005, and Hill, 2001, pp. 91–106); or, architectural theorist, Kath Shonfield, explores how modernist space is contaminated by matter (Hill 2001, pp. 29–44). In each case, architectural boundaries become permeable thresholds through which sexed subjects and bodies are constructed.

Intimate dialogues and encounters with the Other

In the final chapter, I explore Irigaray's use of language, and her analysis of linguistic modes of communication and expression, in order to show the importance of culture and politics for the physical and psychic powers of the sexed subject and sexed spaces. Here, I explore how her interest in tactile and intimate modes of communication may inform understandings of the subject and the formation of spatial relationships in architecture, because she promotes responsive dialogues and productive spaces of social encounter.

Irigaray promotes the sexed subject, and tactile interaction, in order to fundamentally reconfigure the dominant 'architectures' . . .

This discussion also reflects the shift in Irigaray's writing towards more positive notions of engagement and enquiry from the mid 1980s onwards. Not only do these later texts become less abrasive towards other thinkers and their definitions

of subjectivity and spaces of encounter, but Irigaray also develops more concrete cultural definitions of spatial relations for male and female interaction (rather than predominantly philosophical arguments), especially in the books, *Thinking the Difference*, *Democracy Begins Between Two*, *I Love to You*, *To Be Two* and *The Way of Love*. Nevertheless, these more explicitly cultural texts are not any less directed towards releasing notions of intimacy and dialogue from their association with passive feminine values in traditional Western thought. In each case, Irigaray promotes the sexed subject, and tactile interaction, in order to fundamentally reconfigure the dominant 'architectures' of professional or institutional communication and dialogue. By contrast, she argues that unsexed professional forms of dialogue often force different subjects to agree to one single outcome, and define the different participants on the basis of exclusive oppositional hierarchies (e.g. an unfortunately familiar example might be the meeting between a male employer and female employee in which the woman is always expected to defer to the man's ideas). In addition, Irigaray observes that classical forms of philosophical dialogue are often defined by the need for agreement in the interaction (see, for example, the section 'The dialogues' in 1985b, pp. 256–267). Thus, Irigaray's theory of intimate sexed dialogue is distinct from her interpretation of the Socratic (i.e. Platonic) dialogue.

In *To Speak is Never Neutral*, Irigaray develops an unusually positive image of social permeability that takes place in the space of the psychoanalytic consultation (and reflects her own experience as a psychoanalytic practitioner). In the essay, 'The limits of transference', she shows how linguistic and social relations are dynamic permeable thresholds between the analyst and the client. The psychoanalytic consultation is therefore conceived as a space in which the sexed subject is dynamically constructed *in relation to* the analyst. So, rather than the very critical observations of psychoanalysis in her earlier writings, Irigaray suggests that this is a positive dialogue insofar as the dynamic structure of the psychoanalytic encounter generates a permeable boundary between the client's feelings and the analyst's interpretations. She writes:

> Transference comes down to who best perceives the other, who returns the other, or in the other, the closest to his or her source, a gesture that is almost never perceived as bilateral. [. . .] transference becomes the limit

not only of the skin but of the mucous as well, not only of walls but of the most extraordinary experience of intimacy: communication or communion respecting the life of the other while tasting of the very strangeness of his or her desire. Impossible to touch bottom? At the very boundaries of interpretation, beyond which the risk of conflict is most implacable (2002a, p. 245).

In addition, she suggests that the subject's understandings of intimacy and touch therefore underpin his or her ability to engage with the world, and enable his or her boundaries to be kept intact. Irigaray's theory of sexed dialogue therefore means that any encounter must always take into account the Other's power of expression that does not set out to consume or dominate another's subjectivity. Furthermore, Irigaray's theory of 'reciprocity' between the sexes also recognises the need for men to be sexed subjects. This represents a distinct shift in these later writings in which the possibility for a sense-based interaction is also made available *to* men, not just for women, or relations between women. Rather, the value of sense-based thinking for all subjects is expressed, so that sexed thinking and sensing space are not marginalised to the realm of 'women-to-women' communication or omitted altogether. In the context of the architectural profession and architectural education, for example, privileging different subjectivities within a dialogue may inform relations between employers and employees, or tutors and students, by preventing the encounter from being a space of instruction in which the employee or student is always forced to agree with the employer or tutor.

In *I Love To You*, Irigaray develops discussions of respectful touch in a theory of happiness or 'felicity' which, she suggests, may enable the different sexes to live ethically with each other, and through which sensuous, material and political and psychic relationships can be built. In particular, she explores the way in which language can enable ethical dialogues between subjects through 'indirect' forms of grammatical address, for example, in the phrase, 'to the Other'. As a result, Irigaray suggests that openness and contingency are generated in the relationship between subjects, even for those subjects who are most intimately connected:

'It could be that what I love in you – 'to you' – is not consciously willed by you and escapes your intentions: a certain mannerism, a particular expression, a feature of your body, your sensibility. We have to see if we can build a *we* on the basis of what, of *you*, is thus compatible with my intentions but escapes your own [. . .]. On this basis of this *to you* – more a property of yours than an intention assuming this distinction holds – can we construct a temporality? (1996, p. 110).

Then, in the final essay of this publication, she underscores how this shared language of felicity reflects the necessity of touch between subjects, not as a replacement of non-verbal communication, but central to the sexed subject's power to fully express him or herself, and towards the production of positive, shared spaces for living:

Speech is essential between a woman and a man, women and men, but it cannot replace *touching upon*. Speech cannot distinguish between those men and women it claims to bring together, unite, and bring to dialogue. Thus it is important for it to touch and not become the alienation of the tactile in possession, in the elaboration of a truth [. . .] in the production of an abstract and supposedly neuter discourse. Speech must stay as word and flesh, language and sensibility, at the same time (1996, pp. 125–126).

Thus, recovering a sensibility of touch in linguistic forms of communication is also vital to Irigaray's thinking, and these extracts indicate how linguistic expressions reflect their intrinsic sexed origins. For Irigaray, language is a cultural structure that is always informed by our sensory experiences, especially our relationship to touch.

Irigaray's sense-based dialogues with the Other are also reflected in recent research in architectural design, history, theory and practice that seeks to reconfigure histories and theories of sense-based sexed and spatial relations. Collaborative groups who have developed projects which celebrate being in touch with the Other include Muf's urban design and community projects, and Doina Petrescu's Atelier d'Architecture Autogérée's work with women in Senegal, which aims to enable individuals and communities to live positively

in touch and in dialogue with each other. Thus, by keeping 'in touch with' the sexed subject, and his or her senses in a dynamic multi-sexed culture, social, political and spatial 'subject to subject' architectures may be generated across a diverse range of practices, spaces of encounter and modes of interaction.

Dialogue

How do *intimate spaces* enable productive social relationships?

Why are *non-visual perceptions of space* important for architects?

What value do *multi-sensory* methods have for making architectural space benefit the user?

What can *touch-based sensory perception* offer to contemporary design?

What is required in design to make urban spaces places of *constructive encounters*?

What are the important considerations for designing spaces for women and/or *tactile interaction*, e.g. hospitals and maternity wards?

Diagonals, Horizontals and Asymmetry

In this chapter I examine Irigaray's writing about the ways in which scientific thinking defines the physical world and the sexed subject. In addition, I suggest that her interrogations of mathematics- and physics-based disciplines raise important questions about the role of science, which are also relevant for the design and interpretation of architecture.

Scientific thinking is intrinsically connected to the histories, theories and practices that construct physical and psychic experiences. Irigaray interrogates these traditions throughout her writings, particularly in her essays on philosophy and psychoanalysis. In her early texts, Irigaray considers scientific thinking to be

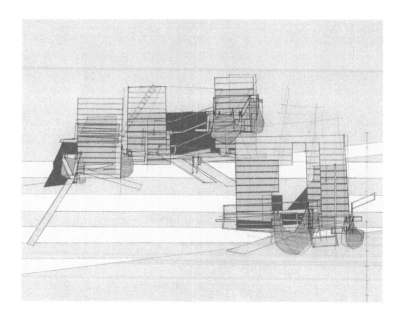

problematic because it excludes the sexed subject and sexed thinking from taking place. Often these essays argue that scientific knowledge is 'blind' to the real material and social relations that actually construct experience. She takes a highly critical stance towards physics' and maths' claims for indisputable universal truths and realities, for example, arguing that they are examples of 'symbolic' thinking, not a truly speculative or sexed thinking. In addition to these critiques of the methods, procedures and aims of modern science, Irigaray also develops an alternative set of qualitative, dynamic, fluid and sexed notions of reality. Speculating on scientific thinking that is sexed and contingent, and which cannot be reduced to single, absolute truths, these discussions may therefore offer interesting ways for architects to explore qualitative and sexed architecture.

Architectural drawing, modelling and thinking require artistic and technical skills and ideas. On a technical level, all buildings must function properly as physical products of scientific principles and procedures. Buildings are evidence of scientific and technical skills and knowledge because their structural organisation and functions can be understood as quantifiable forms, spaces and materials that are produced by the application of linear and objective thinking. Mathematics and scientific thinking are therefore undeniably important skills for the architectural designer. In addition, the architectural designer must learn to use specialist instruments, rules, methods and techniques in order to construct accurately measured and designed spaces which meet the laws of physics. However, the design and inhabitation of the built environment also requires other kinds of thinking to be involved. As the previous two chapters have shown, qualitative, sense-based aesthetic principles are also vital to cultural and social understandings of architecture and its uses. Thus, rather than accounts of architecture that frame it exclusively within the terms of scientific or technological progress, scientific thinking provides architects with one particular kind of knowledge through which buildings are constructed and experienced.

Symbolic thinking

In the essay, 'An ethics of sexual difference', Irigaray gives one of her clearest critiques of scientific understandings of the world. In an exploration of the

productive ethical relations between individual men and women she reveals
how the laws upon which Western thought is 'grounded' fundamentally
prevent the expression of sexed materials, subjects and spaces. Irigaray
considers the various branches of scientific thinking (e.g. maths, physics,
biology), and traditional accounts of architecture, to be especially problematic
paradigms of these principles, because of their claims for objective truths and
general realities that neutralise the different experiences of the sexed subject.
She writes:

> Given that *science* is one of the last figures, if not the last figure, used to
> represent absolute knowledge, it is – ethically – essential that we ask science
> to reconsider the nonneutrality of the supposedly universal subject that
> constitutes its scientific theory and practice (1993a, p. 121).

Developing this discussion, she shows that scientific thinking not only
considers its objects to be universally true, but that the subject is reduced
to a single, homogenous reflection of these universal laws of reason and
intuition. As a result of this dominant system of neutral (i.e. unsexed)
science, together with the unsexed subject, she argues that the physical
and material world is constructed according to the following rules (1993a,
pp. 121–122):

- the subject and world are similar reflections of each other;
- deterministic models of thought are applied to the world;
- the subject and the object are disconnected from each other;
- the senses are removed from the object (e.g. in privileging vision, other
 sensory perceptions are forgotten);
- instrumental forms of knowledge are promoted (e.g. by emphasising
 techniques and instruments of scientific enquiry);
- universal concepts (i.e. the homogenous agreement between diverse
 objects/events) are proved through methods that prioritise scientific
 progression over other kinds of relationship.

Following this attack on the underlying principles of modern scientific thinking,
Irigaray then evaluates the value of different branches of science – physics,

biology, maths, logic, linguistics, economics and psychoanalysis – in order to reveal the *limits* of each method. She argues, for example, that mathematical set theory focuses on open and closed spaces, not fluid, 'half-open' or contingent spaces, and psychoanalysis is underpinned by scientific theories of 'thermodynamics' which are not compatible with the 'dissipation' of energy that defines the psycho-physical experience of female desire (1993a, pp. 123–124).

Later, in the essay 'In science, is the subject sexed?' (1985a), Irigaray returns to this discussion to consider which symbolic *and* social relationships are allowed or disallowed in scientific thinking. She observes, for example, the symbolic representation of an action, object or subject in a 'neutral' symbolic form of a letter or sign (e.g. x, y, z, =, – or %), or the development of a technical language that excludes individuals and communities who are not inside its boundaries:

> Discoveries must be expressed in a formal language, a language that makes sense. And that means: expressing oneself in symbols or letters, substitutions for proper names, that refer only to intra-theoretical objects, and therefore never to any real persons or real objects. The scientist enters into a world of fiction incomprehensible to all who do not participate in it (1985a, p. 251).

In addition, she questions whether any *actual* difference is generated in these methods, because physical science only focuses on quantifiable and mechanical relations, whilst it negates the qualitative differences that occur in the actual contingent, permeable and fluid social and cultural exchanges between it and its subjects (1985a, p. 252). So, for Irigaray, symbolic thinking is a key concept of criticism, characterising systems of thought in which symbols (e.g. words, signs, people, especially women or objects) are taken to represent highly complex conditions or states of reality.

In architecture, for example, symbolic forms of thinking can also be seen in the design process, where the formal techniques and devices of architectural drawing and plan (e.g. the line or geometric figures) are used to represent the complex material and physical qualities of a building. Alternatively, conflicts between the architect and client, and between the building profession and

academic research, may be partly due to the different technical languages that each group uses to interpret architecture.

Universal architectures

Symbolic thinking in architecture and modern science also reflects modern and classical concepts of knowledge that promote the value of universal truths and relationships. Derived from ancient Greek disciplines, such as arithmetic and geometry, modern symbolic thinking is intrinsic to the construction of the physical, material world in Western culture. Furthermore, Irigaray shows that scientific thinking often imitates theological ideas, especially when it is used to confirm concepts of God and divine reason; for example, when scientists argue that objective knowledge exists because it reflects theological laws of divine knowledge, such as modern-day physicists who refer to a 'harmony' between the beauty of the physical laws of the natural world and God's creative powers.

Irigaray argues that Western science's fascination with equivalence is linked to systematic 'architectures'.

Irigaray's critique of modern scientific thinking also involves her in discussing its inheritance of classical Greek science; for example, the problematic inheritance of idealised 'standards' or measurements in Plato's parable of the cave. The section titled, 'The standard itself/himself' outlines this problem; 'But for ideal measurement and ideal value, reference will have to be made to the standard' (1985b, p. 304). According to Irigaray, modern scientific thought inherits this tradition of ideal measurements and values which link unsexed ideas, spaces and objects to the neutral male subject, whilst also excluding and devaluing the role of the sexed subject. As a result, woman is considered to be without rational value or standard in these systems, because she is irreducible to a single 'standard' unit of measurement (1985b, p. 236).

Furthermore, Irigaray argues that Western science's fascination with equivalence is linked to systematic 'architectures'. She describes, for example, how personal

and social relationships are converted into symbolic and economic values which support the production of technical expertise as an end in itself. In the essay, 'Love of same/other' (1993), Irigaray shows how impoverished this symbolic thinking is for women, writing; 'Love of sameness is transformed, transmuted into an architecture of world or worlds, into a system of symbolic and mercantile exchanges. It becomes fabrication and creation of tools and products' (1993a, p. 100). In addition, this systematic production of similar products or spaces dramatically limits women to the status of 'quantitative estimates' and 'nagging calculations' which paralyse the actual fluid nature of desire and love (1993a, p. 103). So, for Irigaray, symbolic thinking assumes that it has the systematic power and techniques to represent *any* event or space, method, subject or object. Valuable for the mechanical translation of ideas into material constructions of the world, Irigaray suggests that its claims for 'truth' in fact ignore the self-referential nature of its systems and procedures upon which it depends.

Alternatively, when Irigaray examines the inheritance of these ideas in Descartes and Spinoza's philosophical methods, she sets out to show that their work is original but is also in thrall to divine reason and the unsexed subject; for example, she shows how Descartes' reliance upon physical laws of *linear* cause and effect underpin the relationship between two disconnected bodies. Descartes' laws, she argues, are derived from his need to construct a harmonious (i.e. homogenous) relationship between God and man, so that man's scientific endeavours are, in effect, imitations of God's powers of creation:

> Each body must try to move without disturbing either the mobility or the repose of the others, without affecting their motivation to move around. [. . .] Should one not presume that the ideally natural tropism would lead them to head in a straight line, one after another, pushing into one another and thus transmitting to each other the divine impulse that is their originary motivation? (1985b, p. 188).

These early essays are therefore sceptical of the assumed 'natural' ability of scientific thinking to construct 'true' expressions of the relationships between

sexed subjects and spaces. However, Irigaray's criticisms of scientific thinking should also be approached with some caution, in particular because she interprets the history of science as an exclusively universal set of practices. In addition, she too can be criticised for her own symbolic and technical forms of writing. Yet her criticism of science and traditional architectonics is also valuable for showing how real physical, intellectual and cultural limitations are placed on the sexed subject, and in her demand that the modern sciences take the needs of the sexed subject into account. In contrast, however, there are other contemporary philosophers and critics of scientific method, for whom the most *productive* way forward is to retrieve lost or overlooked historical examples of qualitative scientific thinking (see, for example, Bruno Latour's *Politics of Nature* (1994), or Isabelle Stenger's *The Invention of Modern Science* (2000)).

For the architect, Irigaray's discussions are most useful for thinking about a qualitative sexed architecture that is not only determined by symbolic thinking or scientific method. In these discussions, architectural techniques and tools such as digital software and hardware, structural and mathematical procedures, do not fulfil *all* the potentials of architectural practice, design and experience. Rather, Irigaray's writing shows that architects need to be mindful of the cultural, social and political limitations for expressing reality that exist in universal claims made for architecture's mechanical, technical and scientific methods.

Diagonals, asymmetry, axes and horizontals

Concepts of space and time are central to the development of Western scientific thought. They are also intrinsic principles in the production of architecture because they are used to construct its physical, material and temporal organisation. In addition, scientific concepts of space and time have been used to inform understandings about the way in which the unsexed subject is composed, and how he or she engages with the world; for example, Cartesian theories of space and time that define the subject as a divided dualistic system of mental perceptions over time and a spatial material body.

Irigaray's investigation into scientific concepts of space and time is strongest in her examination of geometry and arithmetic. In these branches of mathematics,

space is usually represented by geometry (e.g. points, lines, planes, figures and objects) and time is represented by arithmetic (e.g. number, sequences, vectors or movements). In addition, these mathematical constructions of space and time, and application of them into physical forms, are also connected to the engineering, design and technical production of architecture.

Irigaray conducts an intensive analysis of the cultural and scientific values of space in her discussion of Plato's *hystera*. Here, she develops a critique of Platonic geometry in Greek thinking by using a Pythagorean theory of the diagonal in order to show that the sexed subject is omitted from dominant Platonic theories of space. For Irigaray, Pythagoras' scientific thought offers an alternative theory of the world because it does not split the divine and empirical worlds from each other (i.e. the realm of immaterial ideas and physical matter continue to be *interconnected*). Rather, Pythagorean geometry celebrates the complex relationship through irrational numbers and figures (e.g. in the infinite ratios that compose the Pythagorean diagonal, the hypotenuse, or *pi*). She therefore uses the figure of the hypotenuse to show that its irrationality reflects the irrationality of the sexed subject and sexed spaces. In the section titled 'A diagonal helps to temper the excessiveness of the One', she argues that the diagonal represents a significant geometric analogy of the infinite irrationality of woman and the passage, writing:

> Since no estimate in whole numbers is possible, the *diagonal* will supply the excessiveness of a *diaphragm's* non-integrality. [. . .] The geometric construction will have eliminated the reliance on a *root* to which no value can be assigned – in its extraction or its power – because it lacks a common measure with the finite (1985b, p. 358).

Irigaray shows that Plato's story actually contains this 'forgotten' Pythagorean figure of asymmetry and infinity. Thus, the diagonal is a significant geometric figure because it reveals an *irreducible infinity* at the heart of spatial thinking, undermining the pursuit for finite harmony in classical accounts of space and architecture. Instead, the Pythagorean diagonal does not fit neatly into a system of finite rational numbers and systems. For Irigaray, the diagonal and women therefore constitute positive irrational expressions.

Moreover, the diagonal represents an alternative *line* of thinking *between* the normative world of scientific geometry and spatial order, versus the irrational realm of the sexed subject. Irigaray therefore uses the diagonal as a tool of deconstruction through which to challenge Plato's 'division' between the immaterial world of ideas (e.g. mathematics) and the material world of sexed subjects (e.g. the senses). Instead, she argues that the diagonal is a *threshold* through which diverse spaces and times can be constructed (i.e. the diagonal embodies multiple qualities of space and time). Consequently, it undermines scientific theories that consider space and time to be discrete and uniform. So, in its 'deconstructive' role, the diagonal becomes a disruptive figure of 'sexed' scientific thinking (1985b, p. 360). In addition, it is on the cusp of symmetry and asymmetry, order and disorder, disrupting the clear geometric navigation of rational space and time in scientific thought; for example, when Irigaray shows that the cave's association with the irrational and immeasurable qualities of women render it beyond the comprehension of geometric systems:

> The orientation functions by turning everything over, by reversing, and by pivoting around axes of symmetry. From high to low, from low to high, from back to front, from anterior to opposite, but in all cases from a point of view in front of or behind something in this cave, situated in the back. *Symmetry plays a decisive part here* – as projection, reflection, inversion, retroversion – and you will always already have lost your bearings as soon as you set foot in the cave (1985b, pp. 244–245).

Irigaray's arguments reveal an alternative theory of geometry, in contrast to the rational accounts of geometry that suggest Greek geometry is exclusively concerned with symmetry and finitude. In architecture, architects who have explored more indeterminate forms of geometric thinking include: Jennifer Bloomer's play on the golden section and Catharine Ingraham's essay on architectural drawing, Pythagorean geometry and women (Colomina 1992, pp. 163–184 and pp. 255–272); Robin Evans's examination of geometry in *The Projective Cast* (1995); or my study of embodied geometry and 'plenums' (Lloyd Thomas 2007, pp. 55–66).

Property, surveying and division in the 'philosopher's house'

Architectural methods of surveying and measuring also demonstrate how scientific concepts of space are used in the production of housing and domestic space. Frequently, these methods can be taken as the natural solutions to questions about planning and the physical organisation of the home, especially in urban design. For Irigaray, these ordered, divided and rational spaces embody the same limited scientific concepts of space and, as a result, omit the sexed subject. In the essay, 'The looking glass, from the other side', for example, she retells *Alice in Wonderland*, in order to interrogate the way in which the home and woman are understood through scientific properties and processes of quantification. Rather than celebrating Alice's ability to imagine new spaces, Irigaray shows how modern domestic social relations and the built environment are also constructed out of mathematical limits, division and order. For Irigaray, these procedures of measurement and quantification omit the importance of the spatio-temporal social relations that actually construct the domestic home:

> Apparently surveying isn't much use in love. At least not for loving her. How can anyone measure or define, in truth, what is kept behind the plane of projections? What goes beyond those/its limits? Still proper ones. No doubt he can take pleasure in what is produced there, in the person presented or represented. But how can he go beyond that horizon? How can he desire if he can't fix his line of sight? If he can't take aim at the other side of the looking glass? (1985a, p. 18).

Irigaray also brings architectural and philosophical thinking together in relation to Kant's 'architectonic' or systematic philosophy. In the essay, 'Paradox *a priori*', she investigates Kant's concepts of space and time, showing that, although he acknowledges the importance of asymmetrical or imaginary spaces, he relies upon a single subject or point of projection (i.e. his 'Copernican turn') from which all knowledge is constructed, which results in him *building* a homogenous architectonic system of space and time. She writes:

> Thus we can imagine the subject building his house, room by room. And the house is virtually complete: firm foundation, clear title, cellar, stairs, dining

room, dressing room, den, study, corridors, doors, windows, attic [. . .] The fact that it is divided up into different parts in this way is of small matter, provided that each part is subordinated to the whole and never lays claim to being a whole itself, for *that* would not allow man to give a distinct shape to the mystery – or the *hystery* – that is walled up in this harmonious domestic structure (1985b, p. 212).

For Irigaray, Kant's dependence upon a priori scientific thinking means that all systematic disciplines (e.g. architecture or philosophy), their respective producers (e.g. architects, philosophers or surveyors) and objects (e.g. geometry, space or houses), are derived from transcendental ideas of space and time. As a result, the specific differences in the material expression of architecture, embodied ideas and spatio-temporal events, are overlooked. In architecture, designers and critics who have set out to challenge limited forms of a priori thinking in relation to domestic and urban architecture include Alice T. Friedman's historical examination of feminine planning in sixteenth-century Hardwick Hall (Rendell *et al.* 2000, pp. 332–341), or Diana Agrest's designs for San Francisco's china basin that refer to non-Euclidian geometry so as to resist systematic designs of urban planning (Hughes 1996, pp. 200–219). Alternatively, Diller and Scofidio's 'Bad Press' project reveals how the body can disrupt intimate and domestic spaces, and spatial practices (Hughes 1996, pp. 74–95).

Beyond geometry

Irigaray does explore the potential for new qualitative models of scientific thinking. Her most positive assessment of scientific thinking is located in her essays, 'The "mechanics" of fluids' and 'An ethics of sexual difference'. In the first essay, she examines the relationship between the sexed subject's material and psychological qualities of 'fluidity', and the potential in science to express fluid concepts of matter and differentiation:

Is it already getting around [. . .] that women diffuse themselves according to modalities scarcely compatible with the framework of the ruling symbolics. [. . .] So we shall have to turn back to 'science' in order to ask it

some questions. Ask, for example, about its *historical lag in elaborating a 'theory' of fluids*, and about the ensuing aporia even in mathematical formalisation (1985a, p. 106).

Here, therefore, she points to the 'aporia' or gap between scientific theories of finite truths, versus the inherent material infinity (e.g. the diagonal) that lies at the heart of science's systems of representation. Furthermore, her discussions raise the ethical question of who is included or excluded from these scientific desires; for example, when she asks for the opportunity to interrogate 'the scientific horizon [and] to question discourse about the subject of science, and the psychic and sexuate involvement of that subject in scientific discoveries and their formulation' (1993a, p. 125).

The essay 'An ethics of sexual difference' also develops these ethical questions with reference to the work of the physicist, Ilya Prigogine (and his collaborations with the feminist philosopher, Isabelle Stengers), which represents a positive example of qualitative scientific thinking because contingency constructs both the object and the method:

> If a scientific model is needed, female sexuality would perhaps fit better with what Prigogine calls 'dissipatory' structures, which function through exchanges with the exterior world, which proceed in steps from one energy level to another, and which are not organised to search for equilibrium but rather to cross thresholds, a procedure that corresponds to going beyond disorder or entropy without discharge (1993a, p. 124).

Later, in *Thinking the Difference*, written after the Chernobyl nuclear disaster in 1986, Irigaray returns to the need for ethics in the new scientific theories of physical energy, so that account is taken of the difference between 'dissipatory' feminine energy versus masculine or scientific expressions of energy (1989, p. 3). Furthermore, she develops this discussion about feminine dissipation, in order to critique Freud's concept of the subject, and his theory of the production and expenditure of energy in the death drive. In contrast to feminine desire and Prigogine's positive energetic thresholds, she argues that Freud is mistakenly in thrall to negative ideas of masculine energy (1989, pp. 93–97). In addition, this

essay also explores the need for science to engage with social and ethical relations in the world, within the context of contemporary public and political arguments about the dangers of nuclear energy. Twenty years later, these discussions carry a particularly pertinent resonance with current debates about the politics of global developments in nuclear fuel, the environment and sustainable sources of energy production.

. . . she also questions whether scientific disciplines allow or disallow the sexed subject to legitimately exist, as authors and subjects.

Thus, in the context of architectural thinking and practice, Irigaray's discussions of science not only indicate some of the limits of scientific method for the discipline – especially the formalist use of geometric space – but she also questions whether scientific disciplines allow or disallow the sexed subject to legitimately exist, as authors and subjects. Women architects who have examined fluid expressions of geometric thinking include Martine de Maeseneer's Lambrecht House and New Sloten Housing projects, which are developed out of a topological organisation of domestic spaces that discourage linearity, or Françoise-Hélène Jourda's international school complex in Lyons, developed out of complex geometries that aim to subvert deterministic spatial organisation (Hughes 1996, pp. 26–51 and pp. 52–73).

Dialogue

How do *geometric drawings* define internal and external spaces?

How can architects use geometry as a *positive technique* in design?

What benefits of *non-geometric* design might there be?

Can architecture exist without geometry or science, or does its use of these disciplines need to be rethought?

How can sexed thinking improve *scientific thinking* in architecture?

Bridges, Envelopes and Horizons

Irigaray's criticism of scientific thinking in philosophy and psychoanalysis extends to discussions about architecture, when architects ignore contingency in the design, construction and use of buildings; for example, when architectural design is defined as the systematic production of spatial ideas that take little or no account of the client, environmental context or user. Such rigid and inflexible definitions of the discipline rely upon limited scientific definitions of space and result in symbolic and instrumental methods of construction that do not reflect the physical and material complexity of its processes. However, this chapter also shows that Irigaray develops a theory of sexed spaces or architectures that are developed out of fluid, temporal, multi-sensory and multi-dimensional spaces. In the second part of this chapter I therefore explore these productive heterogeneous and irreducible sexed spatio-temporalities or architectures.

Irreducible spatio-temporality

Irigaray interrogates philosophical and psychoanalytic theories of space to show that systematic and unsexed theories of space prevent the 'sexed subject' from actually existing. Under these conditions, space is restricted to either a scientific

concept, or a formless idea. According to Irigaray, the physical sciences, mathematics, and systematic forms of architecture characterise space as: formal, objective, divided, rational, static, symmetrical, unchanging, quantitative, programmatic, external or discrete geometric figures. Such rational accounts of space divide the world into a system of geometric regions and objects into which the individual is placed, and in which similarity and symmetry dominate. Alternatively, she argues that when space is defined as irrational, unintelligible or abstract, it shares its characteristics with women. Both are considered to be formless, excessive, unknowable, unconscious, inaccessible or fragmented. Moreover, in either case, space is reduced to a homogenous and binary value-system; it is either formal space or formless space.

In addition, Irigaray also shows how these unsexed accounts of space also determine ideas about time. Within this traditional hierarchy, time is the 'hand-maiden' of space, imitating and repeating the same dominant relationships and structures. Once again, woman is also associated with time's irrational, indeterminate, unstable and impermanent qualities. Alternatively, when time is defined through rational measurement or the successive repetition of finite units (i.e. rational numbers), women are also assigned the secondary, negative value in the system (i.e. the number 2 always follows after the number 1, and women are second to men). Therefore, women can be associated with an infinite form of rational time. But here, once again, the law of self-similarity defines infinity and women, because it is a repetition of identical values derived from the number 1. Consequently, time and the sexed subject, are limited to infinite imitations of a rational space or a rational number.

According to Irigaray, these limited understandings of space and time therefore determine the way in which the female subject (woman) can operate: either she is rejected from 'proper' scientific space and time or she is associated with the problematic, yet dependent, ideas of formless and timeless space. Neither option offers a 'proper' way to think about space for the sexed subject. In the first part of this chapter, therefore, I look at how these unknowable or immeasurable spaces are negative versions of the sexed subject and sexed space in figures, such as abysses or 'holes'.

Yet Irigaray also draws out a 'third' mode of spatial relations in which the sexed subject is an actively thinking and sensing person. The negative figures of infinite space and time therefore also reveal the *other side* of Irigaray's double-thinking, which embodies the positive expression of the sexed subject and the sexed spaces in which she *and he* can live. These spaces are heterogeneous, topological, irreducible (i.e. they are not reducible to absolute forms or shapes), multi-dimensional, aesthetic, qualitative, deep, psychic, physical and enduring. So, in the second part of the chapter, I explore sexed spaces and poetic spatio-temporal relations (e.g. envelopes, volumes, horizons and bridges) that demonstrate how sexed space and sexed time are irreducible to finite symbols or representations. As a result, Irigaray's writing can offer architects poetic and productive ways through which to construct sexed and sensing histories, practices and interpretations of architecture.

Blind spots, holes and gaps

For the architect, Irigaray's critique of the limits in symbolic representations of space and time raise interesting questions about what can or cannot be legitimately described in architectural space, and what aspects of life may be deemed to fall outside its powers of representation; for example, how do architectural conventions of drawing, modelling and writing enable the production of different spatial senses? What ideas and subjects are omitted or overlooked in these processes? What subjects are considered to be too complex for architectural design, and are therefore rejected as excessive or unnecessary to its aims? How successful is architecture at developing spaces for specific users, if it does not take into account the needs and desires of the sexed subject? (Later in this chapter I give some examples of architectural practices through which to examine some of these questions.)

In *Speculum*, *This Sex*, and *An Ethics of Sexual Difference* Irigaray examines the way in which the sexed subject is considered to be outside norms of representation, for example, in the form of spatial figures, such as 'holes' and 'abysses'. In these discussions, Irigaray draws attention to the way in which space is considered to be infinite because it is immeasurable, unquantifiable or *outside* the structures that represent the world in finite and rational *forms*. For

Irigaray, these discussions therefore reveal the inadequacy of modern symbolic or instrumental systems that limit space and time to finite representations.

Holes and blind spots are present in Irigaray's first publication, *Speculum*, especially in her view that Freud fails to represent the actual social and sexual experiences of girls and women. In the first essay of the book, 'The blind spot of an old dream of symmetry', Irigaray accuses Freud of constructing female sexuality on the basis of 'blind spots', 'voids', 'holes', and the lack of a proper 'original' female sex organ. For Irigaray, Freud misses woman out of his examination of sexual experience – she is a 'hole' in his argument – because she is only present when her sex is 'substituted' with a man's sex. Furthermore, her 'lacking' sexual powers are considered to be a threat to male sexual identity, for example, in the myth of the castration complex. Irigaray spells this out in no uncertain terms:

> Woman's castration is defined as her having nothing you can see, as her having nothing. [. . .] Nothing *like* man. That is to say, no *sex/ organ* that can be seen in a *form* capable of founding its reality, reproducing its truth. *Nothing to be seen is equivalent to having no thing. No being and no truth* (1985b, p. 48).

In psychoanalysis, woman is therefore a threat to its systems of knowledge because she is *outside* its modes of representation. She is a hole in men's signifying economy. A nothing that might cause the ultimate destruction, the splintering, the break in their systems of 'presence,' of 're-presentation' and 'representation' (1985b, p. 49, and 1985a, pp. 24–26). In addition, she writes that Lacan's theory of the subject misrepresents women's psychospatial experiences; for example he writes of identity in what he calls the 'mirror phase', the construction of a distorted view of the world in which, once again, a woman's actual experiences are not seen. Yet Irigaray's critique of Freud also celebrates the sexed subject's powers of disruption in the development of an alternative language of representation, and spaces for the sexed subject.

Two subsequent essays also continue this theme, showing that woman is misrepresented as an immaterial concept in the history of ideas. First, Irigaray argues that Aristotle's philosophy of physics and natural science restricts woman to the inadequate and excessive gap or hole in the system (1985b, p. 165).

Second, in the essay, 'La Mystérique', she explores how a theological representation of ecstatic love (e.g. represented in Bernini's statue of St Teresa) casts woman into a permanent loss of reason (1985b, pp. 194–195). Finally, Irigaray mis-uses the process of mirroring by the curved mirror, the 'speculum', in order to show that these reflections amount to 'holes', not substantial expressions of women's lives (1985b, p. 144).

The essay, 'Volume without contours', however, has one of Irigaray's most intense double-edged examinations of these missing psychospatial holes and gaps in Western thinking, which are drawn out of the different etymological and cultural connotations of the word, 'écart'. Here, she analyses the multiple values of écart as; space, hole, gap, slit or the 'apartness' of woman in language. It is 'the gap, the space, the distance [écart, écartement] in which she finds herself, in which she is a hole again and is holed [se retrou(v)e], [. . .] she will henceforth function as a hole [trou]' (1991b, p. 57). Yet, in the next sentence, écart is also the 'opening' through which Irigaray promotes her economy of sexed spaces that are irreducible, but not merely excessive or immeasurable; 'And for her, metaphor will have the efficacity of a non-violating distance [écart]' if it is 'empty of all appropriated meaning.' The word écart is therefore an important spatial hinge that indicates to the existence of heterogeneous spatio-temporalities. In this particular essay, however, these new sexed spaces cannot ultimately be fully actualised (1991b, pp. 57–66).

In a particularly labyrinthine form of architectural writing, Jennifer Bloomer has explored the spatiality of the line in architectural drawings and writings in *Architecture and the Text: The (S)crypts of Joyce and Piranesi* (1993). Then, in a later essay on this project, Bloomer describes these lines as cracks, which are 'the possibility of architecture', resonating strongly with Irigaray's discussion of the écart (Hughes 1996, p. 244).

Abysses and labyrinths

Irigaray's examination of the 'abyss' (another term for spaces beyond representation) is explored in the essay, 'Così fan tutti', and in her book on Nietzsche, *Marine Lover*. In the first text, Irigaray shows that the holes which

construct the psychic, and hence the linguistic formation of sexed subjects and spaces, are so deep or infinite that they constitute abysses. She writes: 'The lack of access to discourse in the body of the Other is transformed into intervals separating all women from one another. [. . .] But this fault, this gap, this hole, this abyss – in the operations of discourse – will turn out to be obscured as well by another substance: extension' (Irigaray 1985a, p. 98). Moreover, Irigaray equates this particular kind of 'unknowable depth' with rational definitions of infinity which the mathematical operation, topology, relies upon. Challenging how scientific definitions of topological spaces in modern science produce homogenous and indistinct infinities, she writes:

> **The place of the Other, the body of the Other, will then be spelled out in topo-logy. At the point nearest to the coalescence of discourse and fantasy, in the truth of an ortho-graphy of space, the possibility of the sexual relation is going to be missed (1985a, p. 98).**

Here, therefore, Irigaray describes a different relationship between space and time, in which the etymology of '*topos*', meaning 'place', is emphasised, and out of which heterogeneous and particular bodies and places are constructed. Alternatively, in *Marine Lover*, she explores the construction of feminine space in Nietzsche's philosophy. In particular, examining the opposition between the sexed subject and sexed space, versus the transcendental flights and heights

Irigaray describes a different relationship between space and time, in which the etymology of 'topos', meaning 'place', is emphasised . . .

of knowledge that Nietzsche's 'Superman' attempts to reach. In contrast, Irigaray links woman to the irreducible, yet 'creative', depths of the sea, which threaten man's attempts to rationalise and control space (1991a, p. 52). This leads her to suggest that man's failed attempts to 'overcome' the infinity of the world also reveals the irreducible depths and risks that are inherent in the sea and the sexed subject, and which are not accountable to limited forms

of representation. Therefore, the material excesses of woman and the sea represent a forgotten abyss in man's efforts to 'secure' safe 'ground' for his risky desires of omnipotence:

> So, since the bottom has never been sounded, all realities and all truths about it remain on the level of superficial appearances. They move away from the bottom and muddy it with the material they have borrowed from it. That which has never been plumbed still hides in a night far deeper than your day has imagined (1991a, p. 60).

In addition, this text explores the unplanned occurrences, which disrupt rational attempts at problem-solving (of getting to the 'bottom' of a problem), and which may also characterise architectural design methods and practices. Here, therefore, Irigaray develops a critique of goal-driven methods through which the architect can explore how the discipline is constructed on the basis of ensuring secure 'ground', 'footings', 'foundations', and the need for structural and engineering knowledge to develop 'solutions' to these real physical problems, versus the disciplinary anxiety and professional risks that are produced when these solutions are not reached. For discussions of the contingent nature of architectural foundations see, for example, Debra Coleman's introduction (Coleman *et al.* 1996, p. xiii), Elizabeth Grosz's discussion of Irigaray's irreducible ground (2001, pp. 155–162) or Hilde Heynen's analysis of dwelling (Heynen and Baydar 2005, pp. 1–29).

The encounter with Nietzsche also provides a critique of the labyrinth, a spatial figure that architectural designers often associate with Luis Borges' writing (e.g. his collection of stories, *Labyrinths*, 1964). Although an appealing figure of spatio-temporal infinity, Irigaray shows that the labyrinth is descended from Greek mythology in which the sexed subject is primarily defined as 'lost' or a 'reflection' of the male subject (1991a, pp. 69–73). For Irigaray, Nietzsche perpetuates this negative representation of woman's relationship with labyrinths that is most explicitly expressed in the myth of Ariadne, who represents a powerful mythical figure of *feminine* reasoning, and who finds ways out of the labyrinth. However, despite its depth as a spatial figure for the sexed subject, Nietzsche's labyrinth does not endow it with powers of liberation or transformation

embodied in Ariadne's experiences. Instead, woman is still primarily associated with representations of the labyrinth as a space of disorientation, rather than an independently reasoning and sensing sexed subject:

> **She is your labyrinth, you are hers. A path from you to yourself is lost in her, and from her to herself is lost in you. And if one looks only for a play of mirrors in all this, does one not create the abyss? Looking only for attractions to return into the first and only dwelling, does one not hollow out the abyss? (1991a, p. 73).**

This essay is also reminiscent of Irigaray's discussion of Plato's 'receptacle' (the '*hystera*', '*chora*' or passage), another example of an irreducible labyrinthine space, which is 'unknowable' and therefore 'unreasonable' (i.e. beyond reason), for example, when she writes: 'The "receptacle" receives the marks of everything, understands and includes everything – except itself – but its relation to the intelligible is never actually established (1985a, p. 101).

These cautionary words about infinite space-times link to the criticism from architects and architectural critics, who advise architects to retain contingency in the process of design, and warn of the mistaken belief that architectural designs, processes, materials and collaborations can really be controlled by the designer (e.g. Sarah Wigglesworth in Rüedi *et al.* 2000, or Blundell Jones *et al.* 2005). However, I am not also arguing that architecture should give up its technical and scientific knowledge in responding to the real material and environmental needs of the twenty-first century. Rather, Irigaray's writing suggests developing approaches for implementing collaborative multi-sensory, technical, material and verbal languages, which respect the contribution and place of 'others' involved in the production of the built environment. In addition, her writing alerts architectural designers to the need for vigilance against the over-determination of representational techniques in the discipline. Yet she also indicates ways of enriching our powers of listening, engaging with and constructing our physical and social realities. In addition, her writing encourages participants in architecture to respond positively to the different psychic and physical experiences that are inside and outside the discipline's boundaries.

Envelopes, angels, bridges, horizons and thresholds

Throughout Irigaray's publications the importance of 'heterogeneous space-time' (1985b, p. 360) is evident. In the early texts it exists, but it is unreachable. However, in the later texts, especially in *The Way of Love*, it is an achievable 'reality' which is generated out of the encounter between sexed subjects; men and women, philosophers and sexed architects. In contrast to homogenous space and time, sexed spatio-temporality is determined by its inherent differences which exist as realities for all individuals. In the essay, 'When our lips speak', for example, this space-time is haptic (i.e. constructed out of touch). Social and psychic relations between individuals are developed out of their constantly changing psychic and spatial relationships:

> **No surface holds. No figure, line or point remains. No ground subsists. But no abyss, either. Depth, for us, is not a chasm. Without a solid crust, there is no precipice. Our depth is the thickness of our body, our all touching itself. Where top and bottom, inside and outside, in front and behind, above and below are not separated, remote, out of touch. Our all intermingled. Without breaks or gaps (1985a, p. 213).**

In addition, in the context of architecture, heterogeneous space-time may therefore be generated out of sensing and sexed production of the built environment, in which the different needs of the individual are taken into account.

So, instead of the immeasurable infinity of the abyss or hole, heterogeneous space-time is developed out of the contingency of physical and psychic ways of living together with other people in society. Space and time are continuously differentiating inter-dependent relations, rather than logical representations of the same repetitive properties that fix sexed subjects into reductive formal languages or architectures. In the essay, 'Love of the same', for example, Irigaray explores these spatio-temporal relations in the figure of the 'nourishing envelope' that are haptic, bodily and social. In contrast, she argues that the topological figure of the Moebius strip operates on the basis of rational divisions between inside and outside space to produce restrictive 'enclosures' (1993a, p. 105). Alternatively, in another essay in the book called 'The envelope', she criticises Spinoza's limited version of the envelope that does *not* yet allow for

real, heterogeneous, haptic encounters between men and women. The desire for a 'new' way of constructing sexed cultures therefore drives Irigaray's examination of space and time throughout her career, and in the essay, 'Sexual difference', she expresses this desire in a particularly spatial way:

> The transition to a new age requires a change in our perception and conception of space-time, the inhabiting of places, and of containers, or envelopes of identity. It assumes and entails an evolution or a transformation of forms, of the relations of matter and form and of the interval between: the trilogy of the constitution of place (1993a, pp. 7–8).

Also in this essay, Irigaray explores the value of an irreducible, qualitative space-time in the figure of the angel, a theological power, which 'is that which unceasingly passes through the envelope(s) or container(s), goes from one side to the other, reworking every deadline, changing every decision, thwarting all repetition' (1993a, p. 15). Angels therefore represent active agents of transformation in space and time. In their role as messengers and figures of radical change they embody the 'between' or 'interval'. Furthermore, in the form of Gabriel, angels are also associated with the production of sexed spaces and sexed subjects.

Then, in 'Place, interval', Irigaray also presents a critique of Aristotle's disenfranchised space-time in a discussion of 'interval' and 'place'. Irigaray suggests that Aristotle's space-time is infinite, but passive, static and negative. However, she also observes that there are moments of actual transformation, for example, when fluid places are generated in the porous envelope between two bodies (1993a, p. 47). Once again, Irigaray cautiously speculates on the potential for positive concepts of sexed spatio-temporal figures which are haptic and irreducible. Also, later in the book, she shows how the spatial figure of the bridge is latent in Descartes' writing. Overall, she considers Descartes' text to be an account of homogeneous space and time. However, she also suggests that there is a heterogeneous spatio-temporality or bridge latent in the text, which may be available to the sexed subject (1993a, p. 75).

Women architects who have explored the envelope, angel or bridge, include the 'atmospheric' envelopes of Diller and Scofidio's Blur Building (2002) and Françoise-Hélène Jourda's design for the University of Marne la Vallée (1992–1995), which she describes as; 'A thickness. A totally artificial interruption between interior and exterior that negotiates between architecture and the environment' (Hughes 1996, p. 62). Vanessa Chase refers to Irigaray's theory of the envelope and decoration (Coleman 1996, pp. 155–156), and Jane Rendell and Pamela Wells use Irigaray's theory of the angel to rethink spatial relations between art and architecture (Hill 2001, pp. 131–158). Amy Landesberg and Lisa Quatrale's drawing project 'See angel touch' uses 'the cornice of angels' on Louis Sullivan's Bayard Building in New York to create an imaginary additional floor (Coleman et al. 1996, pp. 60–71); and Merrill Elam's reflections on her designs also explore productive bridges between theory and practice (Hughes 1996, pp. 182–199).

Irigaray then calls upon architects to build continuously changing 'thresholds' that embody the physical, tactile and emotional power of relationships between individuals.

Alternatively, one of the most positive space-times that Irigaray constructs is in the gesture of the caress or touch between loving subjects. Here, intimate relations enable 'envelopments', 'horizons' or the 'becoming' of the subject, in relation to the space that the other (subject) inhabits. The sexed subject is produced out of the specific qualities of respect and shared intimacy with the other, constituting a 'becoming in which the other gives of a space-time that is still free' (1993a, p. 207). Also, later in this essay, Irigaray develops one of her most explicit and optimistic references to architectural thinking in a speculation of how to construct the world out of this heterogeneous space-time, desire (or jouissance) when she writes: 'Architects are needed. Architects of beauty who fashion jouissance – a very subtle material. Letting it be and building with it' (1993a, p. 214).

Irigaray then calls upon architects to build continuously changing 'thresholds' that embody the physical, tactile and emotional power of relationships between individuals.

Beatriz Colomina's essay 'Battle Lines: E.1027', for example, presents an architectural interpretation of the horizon when she discusses the desire for 'a new sense of space, a new architecture, in which interior and exterior are no longer clear-cut divisions' when discussing Le Corbusier's use of photography in *Privacy and Publicity* (1996). Colomina writes of how this argument developed from her reading Heidegger's discussion of the horizon; 'In this new sense of space, the traditional distinctions between inside and outside have become profoundly blurred, transforming the role of the architect and modes of subjectivity' (Hughes 1996, p. 4).

In one of her more recent publications, *The Way of Love*, Irigaray also develops a sexed spatio-temporality out of Heidegger's philosophy. This contrasts with her earlier criticism of his ideas in *The Forgetting of Air*, where she argues that his philosophy forgets the importance of different spaces and times to build 'porticos' or 'thresholds' that delimit space and time (1999, pp. 34–35 and p. 96). However, in her later encounter with Heidegger, sexed relations between men and women are possible because time is spatial, but it is not an imitation of space. Instead, Irigaray views Heidegger's notion of time to be irreducible because it is concerned with duration. When it is spatially embodied, time generates open spaces and modes of dwelling. She writes; 'Time itself becomes space, doubles spatiality without for all that surrounding it. Time and space remain open while continuously constituting a dwelling place in which to stay' (2002b, pp. 148–149). Thus, Irigaray opens up Heidegger's thinking for sexed subjects and sexed spaces, in particular, in relation to his theory of 'dwelling' (Sharr, 2007).

In the final section of this book, 'Rebuilding the world', spatial metaphors for sense-based, material and social connections between individuals in society abound. Drawing from the German poet-philosopher, Hölderlin, Irigaray develops a series of particularly architectural expressions of the material and linguistic links in order to build physical 'places' for sexed subject relations, and through which poetic 'houses' or languages can express these relationships:

> Thus to dwell is, according to Hölderlin for example, a fundamental trait of the human condition. But being able to dwell would be tied to the act of constructing: without building, there would be no dwelling. A house, however, could be made of language and to construct could correspond to a poetic activity (2002b, p. 144).

Thus, she describes architectures of poetic construction, which enable life to endure, as 'poetic ways of dwelling' (2002b, p. 152). New gestures enable the irreducible differences of each individual to be actively embodied in the social relations. In addition, any bridge that is constructed between subjects is contingent, never absolutely definitive or fixed (2002b, p. 157). Rather, connections are developed out of the differences between individuals. In this respect, Irigaray calls for a shift in the value placed on 'environments for living, like architecture', from deterministic designs into which the individual is put as an afterthought, into 'supports of the horizon' or expressions of sexed relations (2002b, p. 171).

Reprinted in another recent anthology of Irigaray's essays, *Key Writings* (2004), this final chapter of *The Way of Love* also demonstrates how Irigaray's view of the potential for developing sexed spatio-temporal acts, gestures and languages dramatically shifts from her earlier critical enquiries into space and time. Here, she promotes productive ways to construct 'sexuate cultures' that physically, socially and politically express 'sexuate difference' in the material world, cities, institutions and homes for women *and* men today, and in the future (2004, p. xii). (The essay 'How can we live together in a lasting way?' in this publication, however, also shows that Irigaray's critiques of systematic architectural processes are not always convincing.) Nevertheless, overall Irigaray's later writing suggests a more positive belief that sexed architects exist and construct these new 'poetic ways of dwelling'. Many of the architectural historians, theorists and designers to whom I've referred during the course of this book explicitly desire and explore poetic ways of producing critical and creative sexed architectures. In addition, the reference list at the end of the book indicates further sources through which to explore these diverse methods and practices, and others, in more detail.

Dialogue

Is it possible, or desirable, to control space and movement in an urban environment or a building?

What architectural styles are *forgotten or overlooked* in current architectural design? What are the *gaps of knowledge* in architectural history, theory, criticism and design?

What buildings or building types *challenge or disrupt* our experience of space, and how? In what ways might this be a positive experience?

In what ways is architecture a *spatio-temporal* experience? How do these interpretations help the user to understand architecture?

What historical examples of architecture offer *multiple spatial experiences* for the user?

How can architects build *aesthetic* or *poetic* buildings, which also respond to the different ways in which men, women and children live?

What are the benefits of *horizons* or *contingent thresholds* to architectural design, history, theory and criticism?

Voices, Politics and Poetics

Irigaray's training in philosophy and psychoanalysis informs her discussions of space, time and matter, and the way in which these construct our understandings of architecture. This chapter shows that Irigaray's training in linguistics is also central to her analyses of sexed subjects and spaces. In *Key Writings*, for example, her academic training in linguistics and literature, and her career as a psychotherapist, inform her 'work on language' (2004, p. 35). Irigaray's examination of the politics of verbal expression – i.e. our speech and speech-acts – is present throughout her writings, but is particularly important in *Thinking the Difference*, *I Love to You*, and *Democracy Begins Between Two*. This chapter, therefore, explores how the sexed subject is embodied and

expressed in contemporary cultural politics, language and social institutions, and I suggest ways in which these are important considerations for architecture.

For Irigaray, language is another spatial 'architecture' that expresses or represses the inflections of the sexed subject's desires and needs. In her early texts, Irigaray argues that the sexed subject dwells 'outside' the dominant modes of Western speech, and she develops 'interpretive' or 'deconstructive' readings that release these overlooked meanings from their restricted values. In the later texts, however, sexed *speaking* subjects are not so emphatically positioned in direct opposition to the dominant cultural and institutional discourses, such as architecture. Rather, Irigaray re-examines the potential of 'dialogues', 'encounters between' and 'exchanges' in speech for enabling sexed forms of communication, and writes of the need to develop *real enduring* social and political change in culture, and new political, social and aesthetic languages for women and men.

In addition, Irigaray's writing encourages us to retrieve lost and develop 'new' visual and verbal languages that positively enable sexuate cultures. For the architectural profession this is still an urgent issue, because, although there is a healthy 50:50 ratio of female and male students within architectural education in the UK, the profession is still male-dominated; just 14 per cent of architects are women (see, for example, the Royal Institute of British Architects' 1993 report *Why do women leave architecture?* and the UK's weekly paper for architects, *Building Design's* '50/50 Campaign'). Sexed languages are therefore also vital for the architectural profession to be able to respond politically to, and contribute to, the specific aesthetic, environmental, social, political, economic, historical and cultural contexts in which design takes place.

Politics, dialogues, speech and speech acts

In *Speculum* Irigaray addresses the space of dialogues in Plato's philosophy, which are considered to be paradigms of this philosophical technique for developing dialectical (i.e. opposing) ideas. However, although a dialogue implies that more than one person is speaking, Irigaray suggests that Plato's dialogue on the cave only allows certain (male) voices and ideas to be expressed, whilst other (female) voices either cannot be heard, or their powers

of expression are so undermined that their contribution is overlooked; 'So some speak and others are silent' (1985b, pp. 256–257). This scepticism leads her to analyse 'the conditions under which systematicity itself is possible: what the coherence of the discursive utterance conceals of the conditions under which it is produced' ('The power of discourse', 1985a, pp. 74–75). Thus, for Irigaray, the platonic tradition of dialogue between subjects does not actually constitute a *real* space in which different subject experiences are realised, because its structure still privileges the male speaking subject, not the sexed speaking subject. Rather, she considers it to be a textual and oral space in which the 'sexed subject' is either silent or unheard. For Irigaray, acts of speaking and listening are intensely political arenas. Therefore, her interrogation of how knowledge is constructed in specialist and everyday language also seeks to 'reverse' the organising principles and laws of a discipline, in order to show what is overlooked or missing.

Other 'language work' tactics involve Irigaray in disrupting 'linear reading' or the laws of symmetrical space which underpin discourses such as philosophy and psychoanalysis (and systematic forms of architecture). In addition, her early essays explore the problematic relationship between the 'speaking subject', authorship and authority; for example, in her assessment of patriarchal naming, and its associations with masculine propriety and property ownership. In these spaces, Irigaray argues that the sexed subject is denied a proper place in patriarchal discourse because she is assigned the value of a 'prop' or 'supplement' in the system of meaning, rather than an 'original' subject. In the essay, 'This sex', Irigaray shows how the act of assigning the father's name to the woman expresses a principle of homogeneous identity that subsumes different subjects (i.e. it is a principle of 'self-similarity'). Thus, patriarchal traditions reduce the sexed subject's heterogeneity to a standard value or 'proper name, of proper meaning', in contrast to the sexed subject's multiple states of subjectivity, which cannot be represented by single 'proper' name (1985a, p. 26).

... real conversations and relations between men and women always produce different spaces ...

Yet, Irigaray also uses these strategies to construct a 'feminine style' of expression that generates 'feminine places' in the world. In 'Mechanics of fluids', for example, she explores the link between woman's speech and her multiple states of physical and psychic expression. In this sexed space, a woman's voice, and her use of language, expresses the fluidity of meaning between different modes of expression that do not rely upon the fixed boundaries of 'proper' meanings. Woman's speech is therefore *always* different, contingent upon the different relationships and contexts in which her speech is produced. Each act of speaking is an 'original' event, not a replication of the same idea. Rather, real conversations and relations between men and women always produce different spaces:

> Woman never speaks the same way. What she emits is flowing, fluctuating. Blurring. And she is not listened to, unless proper meaning (meaning of the proper) is lost. Whence the resistances to that voice that overflows the 'subject.' Whence the resistances to that voice that overflows the 'subject' then congeals, freezes, in its categories until it paralyzes the voice in its flow (1985a, p. 112).

Then, in the final essay of this collection, called 'When our lips speak', Irigaray examines the psychosexual importance of language and expression that exists in a woman's body that has two sets of lips, enabling her to express herself in more than one way at the same time (i.e. she has multiple physical powers of expression). In addition, Irigaray argues that the manner in which women interact with each other, in particular how they verbally and physically *express* their love for each other, underpins the way in which they use language, not by defining absolute boundaries and autonomous identities, but in developing intimate spaces of love and desire:

> Open your lips. [. . .] We – you/I – are neither open nor closed. We never separate simply: a single word cannot be pronounced, produced, uttered by our mouths. Between our lips, yours and mine, several voices, several ways of speaking resound endlessly, back and forth. One is never separable from the other. You/I: we are always several at once (1985a, p. 209).

Thus, she draws upon her characterisation of woman's fluid psychosexual desire which constructs both her physical and her linguistic powers of expression at the same time. As a result, language structures and subject-positions, such as 'you', 'I' and 'we', also become contingent and dependent upon their relationship with others, rather than fixed into a series of preassigned roles.

In addition, this quotation highlights the importance of enabling individual expression within a social or disciplinary context, and the ethical dimension of constructing architecture and its discursive spaces. In the essay, 'An ethics of sexual difference', Irigaray argues that contingency between participating individuals is a necessity for the social and political structures of the world; 'A revolution in thought and ethics is needed if the work of sexual difference is to take place. We need to reinterpret everything concerning the relations between the subject and discourse, the subject and the world' (1993a, p. 6).

In a contrasting examination of sexed languages and expression, one of Irigaray's early essays on the psycho-linguistic structures of expression draws from her research into the language of individuals who suffer from mental health issues. Like these women and men, Irigaray argues that the sexed subject is also 'fractured', rather than an enduring and stable linguistic representation of self; for example, because women's talk (e.g. chat, tattle, gossip, fables and myths) is culturally denigrated as 'fiction' or fantasy, in contrast to the 'truth' value attributed to traditionally masculine forms of speech (e.g. discourse, logic, theology, description or narration). In addition, she further distinguishes between the traditions by arguing that the 'content' of women's speech is located within the act of speaking itself – 'The message is the communication' – thereby emphasising the importance of the physical expression of ideas in sexed conversations (1993a, p. 138). In contrast, she argues that the content of patriarchal speech is located outside the subject, in the direction of an external 'God' or a transcendental knowledge or truth (1993a, p. 139). Thus, in this essay, patriarchal forms of language are always determined by their standardisation to an external system of truth, order and symbol, over and above expressing the sexed subject's feelings and thoughts.

Sexuate languages and language structures are therefore crucial for enabling the different communities and individuals in architecture to *express* themselves, and contribute to the discipline's ability to be critical of its methods and creative in its solutions. For the architect, Irigaray's discussion is important for ensuring that the sexed subject is given equal authorship across the discipline's technical languages, institutions and professional structures. It is worth noting, for example, the number of women architects who are joint partners in international architectural firms, yet whose authorship and designs may be presented as secondary to their male partners (or, in some cases, attributed to him). These include Denise Scott Brown and Robert Venturi, Alison and Peter Smithson, Ray Kaiser and Charles Eames, Patty and Michael Hopkins, Nanako Umemoto and Jessie Reiser. Beatriz Colomina (1999 pp. 462–471) and Denise Scott Brown (Rendell *et al.* 2000, pp. 258–265) have explored the personal experiences of women architects who work in collaboration with male partners. Alternatively, collaborative practices, such as Muf (and, previously, Matrix), have chosen to work under a collective name, in order to resist issues of naming, authorship and mis-appropriation, and to promote collective non-hierarchical working practices.

Building sexuate languages

Irigaray's writings since 1989 explore the politics of contemporary social spaces of language more concretely, and show her interest in cultural spaces of political and social change, which are not just located inside traditional academic disciplines. In particular, her association with the Italian Communist Party, the women's movement, and Italian feminist thinkers, such as Livia Turco, inform these discussions. In addition, the physical and social fabric of the spaces in which Irigaray conducts these discussions are more explicitly developed within the context of non-academic political and social cultures, such as public debates and political meetings, rather than taking place in formal academic teaching contexts.

Also, these later texts are characterised not so much by their attack on a disciplinary authority, but by their description of laws and cultural structures, especially language. They highlight the shift in Irigaray's thinking towards a

theory of 'sexuate culture' that is accessible and intrinsic to the spiritual, ethical, social, mental, political and aesthetic needs of the sexed individual; for example, when she describes the book, *To Speak Is Never Neutral*, as 'a questioning of the language of science, and an investigation into the sexualisation of language, and the relationship between the two' (2002a, p. 5).

In the essay, 'Linguistic and specular communication', she criticises the technical, scientific traditions of discourse (e.g. philosophy and psychoanalysis) for operating with laws that generate inflexible forms of communication, and building 'closed off' houses of language that exclude the sexed subject (2002a, p. 5). She develops a psychosexual analysis of the asymmetric value placed on the pronouns 'I' and 'you' in psychoanalysis through which, she argues, the sexed subject is denied in the process: 'In their initial non-reversible relation, <I> and <you> make up <one>. Lack of differentiation of persons, of the identical and the non-identical, this <one> is already the possibility of their future disjunction' (2002a, p. 11).

Therefore, for Irigaray, privileged modes of speaking (i.e. discursive or logical thinking) ignore the specific needs and desires of the individual to whom they refer; for example, when psychoanalysis refuses to recognise the positive value of the sexed subject as woman, mother and child in culture. Later in the essay, she links this problematic linguistic fracturing of the sexed subject to other psychological states of fragmentation which have historically and culturally been associated with the loss of subjectivity (e.g. psychosis or hysteria in women). This issue further underscores her belief that the relationship between language and the subject is a mental health issue for the sexed subject (2002a, pp. 19–22). For Irigaray, the structure of language is therefore intrinsically linked to the ethical and political expression of all sexed subjects, women *and* men, and the construction of 'sexuate cultures'.

Three books, *Thinking the Difference*, *I Love to You* and *Democracy Begins Between Two*, particularly focus on developing a political language for the sexed subject, together with Irigaray's more explicitly political exploration of a socially and culturally embedded sexuate language. In these later texts, Irigaray shifts her argument from the analysis of disciplinary discourses, language and

ideas, into the realm of contemporary political debate and campaign for equality in Europe. She examines its importance for feminism and the women's movement, especially with reference to debates taking place in the Italian Communist Party (PCI) in Bologna, and her own dialogue with the Italian politicians, Livia Turco and the then Mayor of Bologna and MEP, Renzo Imbeni. As such, these books explore the need to build socio-political structures through which the *sexed citizen* can express his or her needs and desires:

> Re-defining rights appropriate to the two sexes to replace abstract rights appropriate to non-existent neutral individuals, and enshrining these rights in the law, and in any charter constituting some sort of national or universal declaration of human rights, is the best way for women to hold onto rights already gained, have them enforced, and gain others more specifically suited to female identity (1989, p. xv).

Non-sexuate cultures and languages, however, actively prevent women (and sexed architects), from speaking and from being heard (1989, p. xv). *Thinking the Difference* addresses this issue by emphasising the importance of language in the 'production of meaning' because it establishes 'forms of social mediation, ranging from interpersonal relationships to the most elaborate political relations'. As a result, Irigaray promotes the need for giving 'both sexes equivalent opportunities to speak and increase their self-esteem', and she warns of the dangers of a language that does not express multiple subject positions (1993c, p. xv).

In the later publication, *I Love to You*, Irigaray goes on to develop a series of essays about 'sexuate culture' that are generated from her discussions with Renzo Imbeni during the early 1990s. In the 'prologue' to this text, she writes of their initial encounter in the space of a public meeting, describing how Imbeni supported her unscheduled last-minute change to the 'protocol' of the evening in which she requested that men and women took turns to ask questions of herself and Imbeni (1996, pp. 7–9). In addition, she describes their shared interest in making democratic change *possible*: for Imbeni, as a politician in the European Parliament and the Italian political system, this is directed towards building democratic civic life in the city of Bologna; for Irigaray, as a citizen who

supported Imbeni's political election, and whom calls herself 'a political militant', this ambition is directed towards turning the 'impossible' into the possible (1996, p. 10).

Later in the book Irigaray examines the need to produce a new set of relations that ensure the differences between subjects are established in language. She ends the chapter by calling for this new psychospatial relationship between men and women to be expressed in a way that retains the spatial and linguistic differences between each subject. In addition, she calls these: 'indirect relations [. . .] relations founded upon a form of indirection or intransitivity. And so: I love to you, rather than: I love you' (1996, p. 102).

Here, Irigaray disrupts the common usage of the verb 'love', from its role as an expression of 'transitive' verb (i.e. an action which is *directed* towards a *specific* object or subject), into an 'intransitive' verb, in which there is *no direct* object or subject. This indirect relationship between two subjects is also spatially marked by the insertion of the preposition 'to' into the action (1996, 102). Then, explaining the potential of this 'syntax of communication' (1996, p. 113) for enabling respectful, ethical intersubjectivity between men and women in this 'indirect' relationship where neither subject attempts to own the other, she writes: '*I love to you* is the guarantor of two intentionalities: mine and yours. In you I love that which can correspond to my own intentionality and to yours' (1996, p. 110).

Furthermore, this revision of social interaction also opens up the reciprocity of the speech act in the act of listening; as in, 'I am listening to you'. For Irigaray, this means; 'I perceive what you are saying, I am attentive to it, I am attempting to understand and hear your intention. Which does not mean: I comprehend you, I know you, so I do not need to listen to you and I can even plan a future for you' (1996, p. 116).

Irigaray's discussions about sexuate languages and political action are important for the development of *sexuate architectures*.

Given the cultural and professional definition of the architect to construct, plan and design the world for heterogeneous cultures, Irigaray's discussions about sexuate languages and political action are important for the development of *sexuate architectures*. Practitioners who have also explored these issues include: Mark Wigley's essay, 'Untitled: the housing of gender' (Colomina 1992, pp. 327–389); Jane Rendell's examination of Irigaray's intransitive dialogue in the relationship between art and architectural practices (2006, pp. 150–151); Katerina Rüedi Ray's essay, 'Bauhaus dream house: forming the imaginary body of the ungendered architect', which calls for a need to re-evaluate the modern architectural teaching institution, in her examining the 'utopian' unsexed architectural practice and identity established in the teaching practices of the Bauhaus during the 1910s and 1920s (Rüedi *et al.* 1996, pp. 161–174); bell hooks' discussion of the political power of dialogues between practice and theory (Rendell *et al.* 2000, pp. 397–398); and Doina Petrescu's collaborative work with women in Dakar, promoting the collective power of women in the modern African city (Lloyd Thomas 2007, pp. 225–236). In addition, each chapter of this book has referred to other architects, historians, theorists and critics who explore these issues, towards developing creative and political expressions and solutions that promote enduring and productive sexuate architectures for today's and future societies.

Dialogue

How do architects *speak* about their profession?

Who is *included or excluded* from these discussions?

What are the *official and unofficial* conversations that take place in the profession?

Are architects (men and women) encouraged to use *feminine or sexed modes of expression* in architecture?

What benefits could a *sexed language* have for architecture?

What are the *sexed spaces of language* that are shared between architectural design, history, theory and criticism?

Appendix: Guidance for Reading Irigaray

Irigaray's writing style can be dense and technical, making her books a challenging experience to read. Some of the most complex texts are characterised by her use, and creative mis-use, of another thinker's terminology in order to reveal the problems, gaps, holes or overlooked meanings in their ideas. Since the 1990s Irigaray has written useful summaries of her earlier, more technical, writings, in particular, in the introductory essays to *The Irigaray Reader* and *Key Writings*. Therefore, readers may find it useful to go to these sections before attempting to read other texts. However, 'slow' reading may also be a useful technique to aid an individual or small group of readers towards understanding specific texts. Below, I outline a method of generating dialogues for reading texts; for example, from the essay, 'This sex which is not one'.

1 Divide the essay up into equal sections between the group. You will see that the text is already divided into sections and 'fragmentary' passages, so use these.

2 Give yourself plenty of time to read your section, e.g. a week. Expect to read the section at least three times, and do not be alarmed if you need to read it more. You may find it useful to read the text fairly quickly at first, and then work more slowly through it on each subsequent reading, making notes about terms or expressions you do or don't understand. If you find it very difficult, concentrate on a single paragraph or page, rather than failing to write any comments about any of the text.

3 If you have time, you can also help your understanding by reading one of Irigaray's summaries about her project. She gives various names to this project, including 'feminine philosophy', 'feminine discourse', 'subject-subject culture', 'a culture of two subjects', 'being-with-the-other'.

4 Write down three questions or comments about what you have read, e.g.;

 i Explain the meaning of three new ideas or words.

 ii What ideas do you, or don't you understand, and why?

 iii Write a short description of the main argument in the text.

Also, remember that one of the important ways in which Irigaray communicates her ideas is through the text layout and her repetition of terminology.

5 At your next meeting, discuss what you think the selected text is about. Before you leave your meeting, write a short (50 word) summary of what you think the text explores. You will find it useful not to reduce it to just one idea.

6 Suggest four ways in which her ideas are useful to architects. You may wish to think about the following questions, for example;

 i Do her ideas challenge the way in which forms and shapes of architecture are made?

 ii What kind of material structures in architecture relate to her writing?

 iii What kind of processes of manufacture and production does she promote?

 iv What kind of space can the user occupy? Is it static, mobile, easy or difficult to orientate around?

 v What kind of occupant is described? Is this person physically or psychologically disconnected from their environment and other people? Are they connected to their environment in the form of responses to materials? Are they connected to other people who live in the environment or occupy the same space?

Bibliography of Works Cited

A more comprehensive bibliography of Irigaray's work can be found in *Key Writings*. Below I also list suggestions for further readings, including examples of architectural history, theory and design research into architecture and women, gender and feminism over the past 30 years. There is not enough space here to provide a full bibliography of all individual contributors to edited collections and anthologies. Therefore, please refer to the index for a full list of authors that are cited during the course of the book.

Secondary sources

Adams, Peter (1987) *Eileen Gray, Architect/Designer*, New York, Harry N. Abrams.

Agrest, Diana, Conway, Patricia and Kanes Weisman, Leslie (eds) (1996) *The Sex of Architecture*, New York, Harry N. Abrams.

Bloomer, Jennifer (1993) *Architecture and the Text: The (S)crypts of Joyce and Piranesi*, New Haven, CT: London, Yale University Press.

Blundell Jones, Peter, Petrescu, Doina and Till, Jeremy (eds) (2005) *Architecture and Participation*, London, Spon Press.

Building Design, 2005, '50/50 Campaign', Issue No. 1655, Friday, 8 January.

Cole Doris (1973) *From Tipi to Skyscraper: A History of Women in Architecture*, New York, G. Braziller.

Coleman, Debra, Danze, Elizabeth and Henderson, Carole (eds) (1996) *Architecture and Feminism*, New York, Princeton Architectural Press.

Coles, Alex (1999) *The Optic of Walter Benjamin*, London, Black Dog Publishing.

Colomina, Beatriz (ed.) (1992) *Sexuality and Space*, New York, Princeton Architectural Press.

—— (1999) 'Collaborations: the private life of modern architecture', *The Journal of the Society of Architectural Historians,* Vol. 58, No. 3, *Chicago, Society of Architectural Historians.*

Documenta 11: Platform 5 Catalogue. 2002, Kassel: Ostfildern-Ruit, Hatje
 Cantz: Verlag.

Friedman, Alice T. (1988) *Women and the Making of the Modern House:
 A Social and Architectural History,* New York, Abrams.

Grosz, Elizabeth (1995) *Space, Time, and Perversion: Essays on the Politics of
 Bodies,* London: New York, Routledge.

—— (2001) *Architecture from the Outside: Essays on Virtual and Real Space,*
 Cambridge, MA: London, MIT Press.

Hayden, Dolores (1984) *Redesigning the American Dream: The Future of
 Housing, Work, and Family Life,* New York: London, W.W. Norton.

Heynen, Hilde and Baydar, Gülsüm (eds) (2005) *Negotiating Domesticity:
 Spatial Productions of Gender in Modern Architecture,* London: New York,
 Routledge.

Hill, Jonathan (2001) *The Subject is Matter,* London: New York, Routledge.

Hughes, Francesca (ed.) (1996) *The Architect: Reconstructing Her Practice,*
 Cambridge, Massachusetts: London, MIT Press.

Irigaray, Luce (1985a) *This Sex Which Is Not One,* trans. by Catherine Porter with
 Carolyn Burke, Ithaca; NY, Cornell University Press. [1977, *Ce sexe qui n'en
 est pas un,* Paris, Editions de Minuit.]

—— (1985b) *Speculum of the Other Woman,* trans. by Gillian C. Gill, Ithaca:
 New York, Cornell University Press. [1974, *Speculum de l'autre femme,* Paris,
 Editions de Minuit.]

—— (1991a) *Marine Lover: Of Friedrich Nietzsche,* trans. by Gillian C. Gill, New
 York, Columbia University Press. [1980, *Amante marine, de Friedrich
 Nietzsche,* Paris, Editions de Minuit.]

—— (1991b) *The Irigaray Reader,* edited by Margaret Whitford, Oxford:
 Cambridge, Basil Blackwell.

—— (1993a) *An Ethics of Sexual Difference,* trans. by Carolyn Burke and
 Gillian C. Gill, Ithaca: New York: London, Cornell University Press:
 Continuum. [1984, *Ethique de la différence sexuelle,* Paris, Editions de
 Minuit.]

—— (1993b) *Je, tu, nous, Towards a Culture of Difference,* trans. by Alison
 Martin, London-New York, Routledge. [1990, *Je, tu, nous, Pour une culture
 de la différence.* Paris, Grasset.]

—— (1993c) *Thinking the Difference: For a Peaceful Revolution*, trans. by Karin Montin, London–New York, Continuum-Routledge. [1989, *Le Temps de la différence, Pour une révolution pacifique*, Paris, Libraire Générale française, Livre de poche.]

—— (1996) *I Love to You: Sketch of a Possible Felicity in History*, trans. by Alison Martin, London: New York, Routledge. [1992, *J'aime à toi, Esquisse d'une félicité dans l'Histoire*, Paris, Grasset.]

—— (1999) *The Forgetting of Air: In Martin Heidegger*, trans. by Mary Beth Mader, Austin: London, University of Texas Press: Continuum. [1983, *L'oubli de l'air, Chez Martin Heidegger*, Paris, Editions de Minuit.]

—— (2001a) *Democracy Begins Between Two*, trans. by Kirsteen Anderson, London: New York, Routledge. [1994, *La democrazia comincia a due*, Turin, Bollati Boringhieri.]

—— (2001b) *To Be Two*, trans. by Monique M. Rhodes and Marco F. Cocito-Monoc, London: New York, Athlone: Routledge. [1994, *Essere Due*, Turin, Bollati Boringhieri.]

—— (2002a) *To Speak is Never Neutral*, trans. by Gail Schwab, London: New York, Continuum. [1985, *Parler n'est jamais neutre*, Paris, Editions de Minuit.]

—— (2002b) *The Way of Love*, trans. by Heidi Bostic and Stephen Pluhácek, London: New York, Continuum.

—— (2004) *Key Writings*, London: New York, Continuum.

Kanes Weisman, Leslie (1992) *Discrimination by Design: A Feminist Critique of the Man-made Environment*, Urbana; IL, University of Illinois Press

Lloyd Thomas, Katie (ed.) (2007) *Material Matters: Architecture and Material Practice*, London: New York, Routledge.

Rendell, Jane (2002) *The Pursuit of Pleasure: Gender, Space and Architecture in Regency London*, London, The Athlone Press, Continuum: Rutgers University Press.

——, Penner, Barbara and Borden, Iain (eds) (2000) *Gender Space Architecture: An Interdisciplinary Introduction*. London: Routledge.

—— (2006) *Art and Architecture: A Place Between*, London, I.B. Taurus.

Royal Institute of British Architects (2003) 'Why Do Women Leave Architecture?' Report Response and RIBA Action, July, London, RIBA.

Rüedi, Katerina, Wigglesworth, Sarah and McCorquodale, Duncan (eds) (1996) *Desiring Practices: Architecture, Gender, and the Interdisciplinary*, London, Black Dog Publishing.

Samuel, Flora (2004) *Le Corbusier: Architect and Feminist*, London, Wiley.

Sharr, Adam (2007) *Heidegger for Architects*, Oxon, Routledge.

Torre, Susana (ed.) (1977) *Women in American Architecture: A Historic and Contemporary Perspective*, New York, Whitney Library of Design.

Wilson, Elizabeth (1991) *The Sphinx in the City: Urban Life, the Control of Disorder, and Women*, Berkeley, CA: Los Angeles: Oxford, University of California Press.

Wright, Gwendolyn (1981) *Building the Dream: A Social History of Housing in America*, New York, Pantheon Books.

Further Reading

Adams, Annmarie and Tancred, Peta (2000) *Designing Women: Gender and the Architectural Profession*, Toronto: Buffalo, University of Toronto Press.

Agrest, Diana (1991) *Architecture from Without: Theoretical Framings for a Critical Practice*, Cambridge, Massachusetts: London, MIT Press.

Anthony, Kathyrn H. (2001) *Designing for Diversity: Gender, Race, and Ethnicity in the Architectural Profession*, Urbana, IL, University of Illinois Press.

Battersby, Christine (1998) *The Phenomenal Woman: Feminist Metaphysics and the Patterns Of Identity*, Cambridge, Polity Press.

Berkeley, Ellen Perry (ed.) (1989) *Architecture: A Place for Women*, Washington, Smithsonian Institution Press.

Bloomer, Jennifer (ed.) (1994) 'Architecture and the feminine: mop-up work, any', *Architecture New York*, Special Issue, No. 4, January–February.

Borden, Iain and Rendell, Jane (eds) (2000) *Intersections: Architectural Histories and Critical Theories*, London: New York, Routledge.

Burke, Carolyn, Schor, Naomi and Whitford, Margaret (eds) (1994) *Engaging with Irigaray: Feminist Philosophy and Modern European Thought*, New York, Columbia University Press.

Butler, Judith (1993) *Bodies that Matter: On the Discursive Limits of 'Sex'*, London: New York, Routledge.

Durning, Louise and Wrigley, Richard (eds) (2000) *Gender and Architecture*, Chichester: New York, Wiley.

Elam, Diane (1994) *Feminism and Deconstruction: Ms. En Abyme*, London: New York, Routledge.

Florence, Penny (2004) *Sexed Universals in Contemporary Art*, New York, Allworth Press.

Hayden, Dolores (1982) *The Grand Domestic Revolution: A History of Feminist Designs for American Homes, Neighbourhoods and Cities*, Cambridge, MA, MIT Press.

Heynen, Hilde (2000) 'Places of the everyday: women critics in architecture', *Archis*, No. 4, April, pp. 58–64.

Holmes Boutelle, Sara (1988) *Julia Morgan, Architect*, New York, Abbeville Press.

Lloyd, Genevieve (2002) *Feminism and History of Philosophy*, Oxford, Oxford University Press.

Lorenz, Clare (1990) *Women in Architecture: A Contemporary Perspective*, New York, Rizzoli.

McLeod, Mary, (2004) 'Reflections on feminism and modern architecture', *Harvard Design Magazine*, No. 20, Spring–Summer, 64–67.

McQuiston, Liz (1988) *Women in Design: A Contemporary View*, London, Trefoil.

Matrix Organization (1985) *Making Space: Women and the Man-Made Environment*, London, Pluto Press.

Penner, Barbara and Rice, Charles (eds) (2004) 'Constructing the Interior', *The Journal of Architecture*, Vol. 9, No. 3, Autumn.

Plant, Sadie (1997) *Zeros + Ones: Women, Cyberspace + The New Technoculture*, London: New York, Doubleday: Fourth Estate.

Rice, Charles (2006) *The Emergence of the Interior*, New York: Oxon, Routledge.

Roberts, Marion (1990) *Living in a Man-Made World: Gender Assumptions in Modern Housing Design*, New York, Routledge.

Sanders, Joel (ed.) (1996) *Stud: Architectures of Masculinity*, New York, Princeton Architectural Press.

Searing, Helen (1998) *Equal Partners: Men and Women Principals in Contemporary Architectural Practice*, Northampton, Smith College Museum of Art.

Such, Robert (2000) 'A Quiet Revolution: Women in French Practice', *Architectural Design*, Vol. 70, No. 5, October, 94–97.

Toy, Maggie and Pran, Peter C. (2001) *The Architect: Women in Contemporary Architecture*, Chichester: Wiley-Academy.

Vasseleu, Cathryn (1998) *Textures of Light: Vision and Touch in Irigaray, Levinas, and Merleau-Ponty*, London: New York, Routledge.

Walker, Lynne (ed.) (1997) *Drawing on Diversity: Women, Architecture and Practice,* London, RIBA.

Whitford, Margaret (1991) *Luce Irigaray: Philosophy in the Feminine*, London:

Whitford, Margaret (1991) *Luce Irigaray: Philosophy in the Feminine*, London: New York, Routledge.

Whitman, Paula (2006) 'How do women fare in architecture?', *Going Places, Architecture Australia*, vol. 95, no. 1, January, pp. 47–53.

Willis, Julie and Hanna, Bronwyn (2001) *Women Architects in Australia, 1900–1950*, Red Hill, A.C.T, Royal Australian Institute of Architects.

Index